GREAT
PHOTOGRAPHERS
of the
AMERICAN WEST

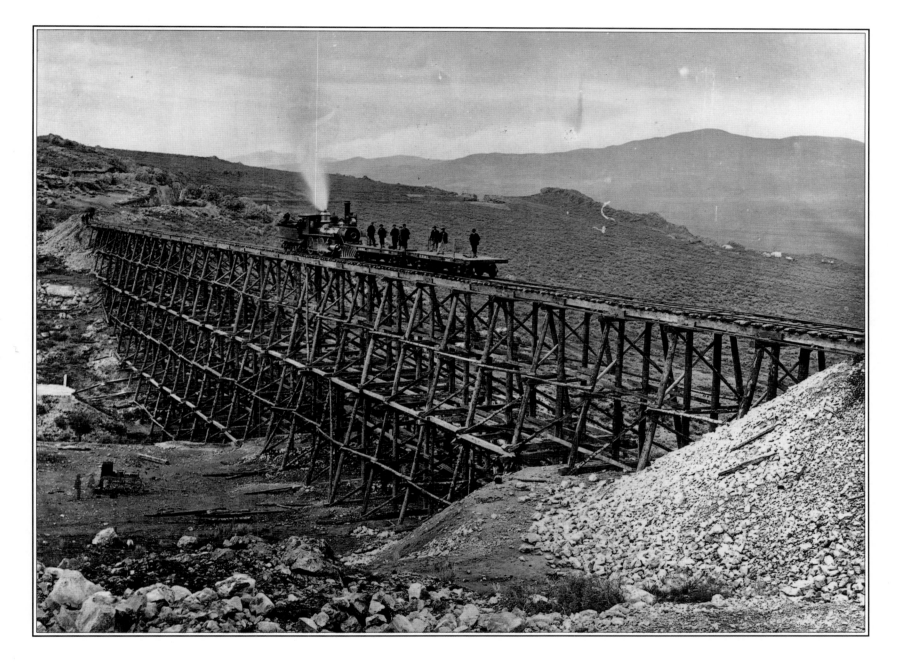

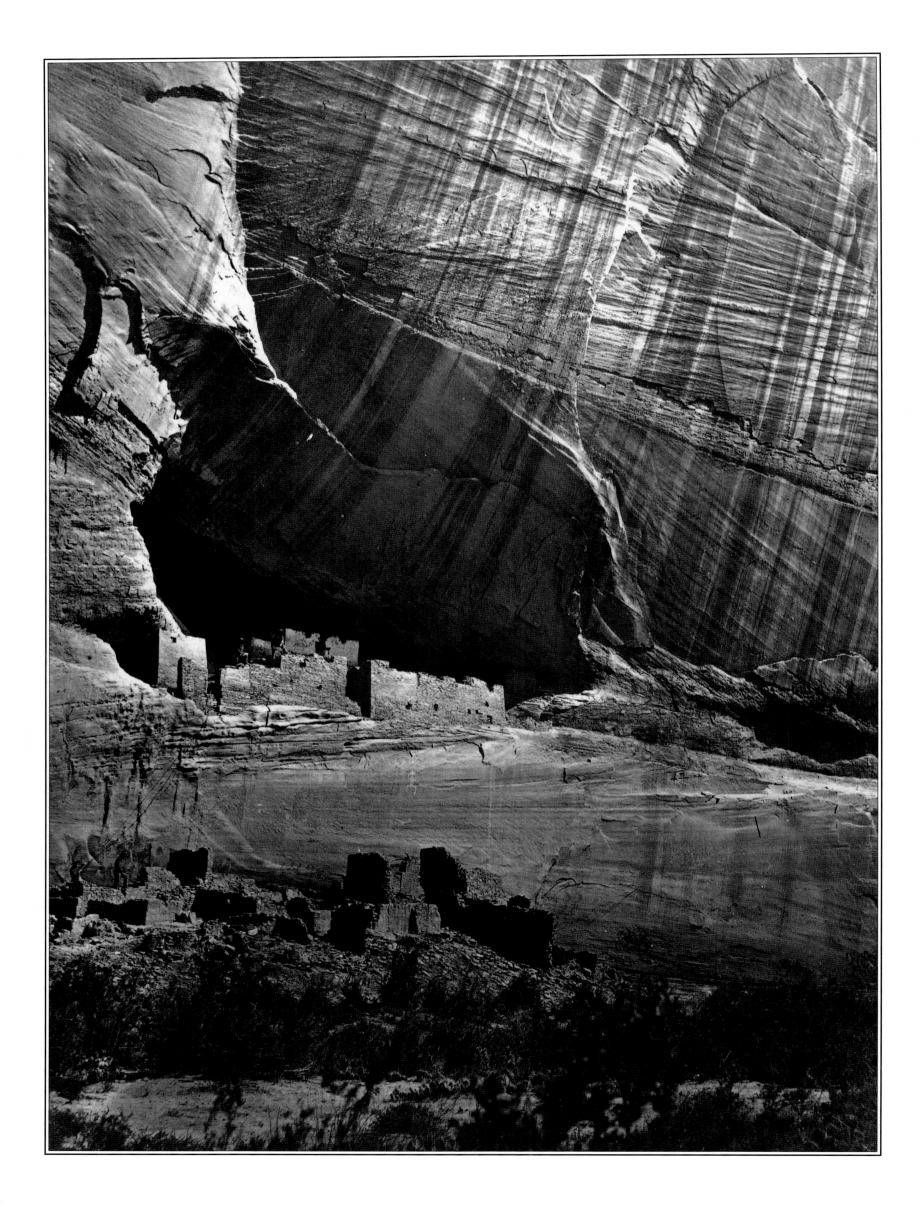

GREAT PHOTOGRAPHERS of the AMERICAN WEST

Eva Weber

CHARTWELL
BOOKS, INC.

Published by
CHARTWELL BOOKS, INC.
A Division of **BOOK SALES, INC.**
110 Enterprise Avenue
Secaucus, New Jersey 07094

Produced by
Brompton Books Corp.
15 Sherwood Place
Greenwich, CT 06830

Copyright © 1993 Brompton Books Corp.

ISBN 1-55521-869-5

Printed in Hong Kong

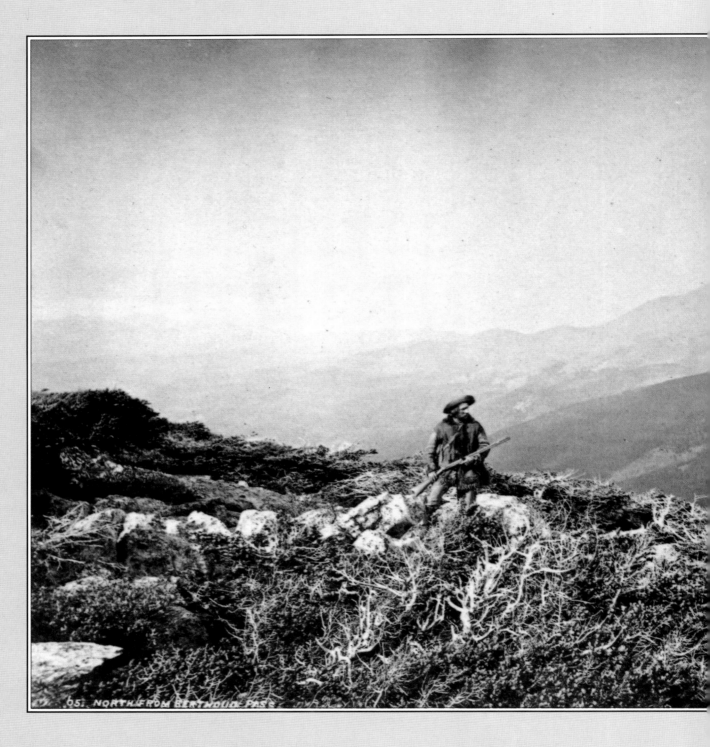

PAGE 1:
Andrew J. Russell
Trestle at Promontory, Utah

RARE BOOK DEPARTMENT, HISTORICAL PHOTOGRAPHS
THE HUNTINGTON LIBRARY, SAN MARINO, CA

PAGE 2:
Timothy O'Sullivan
*Ancient Ruins in the Canyon de Chelly, New Mexico
(territory), 1873*

PHOTO ARCHIVES, MUSEUM OF NEW MEXICO
SANTA FE, NM

PAGES 4–5:
William Henry Jackson
North from Berthoud Pass

BEINECKE RARE BOOK AND MANUSCRIPT LIBRARY
YALE UNIVERSITY, NEW HAVEN, CT

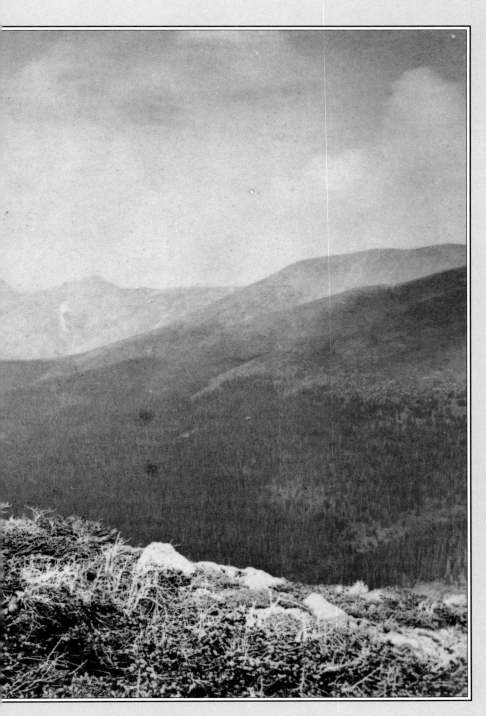

CONTENTS

Introduction 6

Artistic Visions 19

Scientific Explorations 41

The Native Americans 63

Manifest Destiny 91

List of Photographs 112

INTRODUCTION

ABOVE: *Alexander Gardner was one of several photographers to hone his skills during the Civil War. Here is his photograph of Civil War officers near Petersburg, Virginia, 1864.*

"S ave the shadow ere the substance fades" was a slogan that sold photographs in the days of the Old West. True, these words had a special meaning when sons, brothers and husbands marched off as soldiers to the Civil War, perhaps never to return, or when whole families loaded up covered wagons to begin the hazardous trek westward in search of a new home, perhaps to fall victim to the dangers of the trail and never to be seen again. Consciousness of the transience of life during a time of swift and unpredictable change informed the need to permanently preserve the faces of loved ones and the material of a disappearing world. A deliberate effort to document a vanishing way of life motivated much of the best photography of what is now regarded as the legendary Old West.

In the second half of the nineteenth century, the landscape photographers – Carleton E. Watkins, Eadweard Muybridge, Timothy O'Sullivan, Andrew J. Russell and William Henry Jackson, and others – working either for themselves or for government and railroad survey expeditions, sought to capture the pristine and majestic western scenery, still a veritable Garden of Eden, before it inevitably was corrupted and despoiled. And they were able to save for science – at least on glass plate negatives – specimens of primeval towering trees before they could be chopped down for lumber, as

well as teetering boulders, fragile stone columns and yawning chasms before they fell prey to the depredations of rain, wind, sand, earthquake or vandal.

A similar urgency inspired Solomon D. Butcher to photograph Nebraska homesteaders and collect their oral history for his record of the pioneer saga. In the Southwest, E. E. Smith, suspecting the transitory quality of the great cattle ranching era, made haste to record for posterity the everyday activities of the cowboy on the range. The Native American, in the persona of the "Vanishing Indian" and "Noble Savage," was catalogued by Edward S. Curtis. As assembled by photographers, this portrait of the West may be colored at times by romantic preconceptions, artistic pretension, religious sentimentality, nationalist fervor and ethnocentric bias, but in the end it is a revelatory and irreplaceable historic record.

Even during the earliest days of the nation, the West assumed mythic status. Americans projected all their optimistic hopes and dreams on this Promised Land, a place of untold riches and boundless opportunities. This vision was confirmed and perpetuated by literature and art. The paintings of Charles Bird King and George Catlin portrayed the Native American as an aristocratic presence, and decades later the spectacular western landscape paintings of Albert

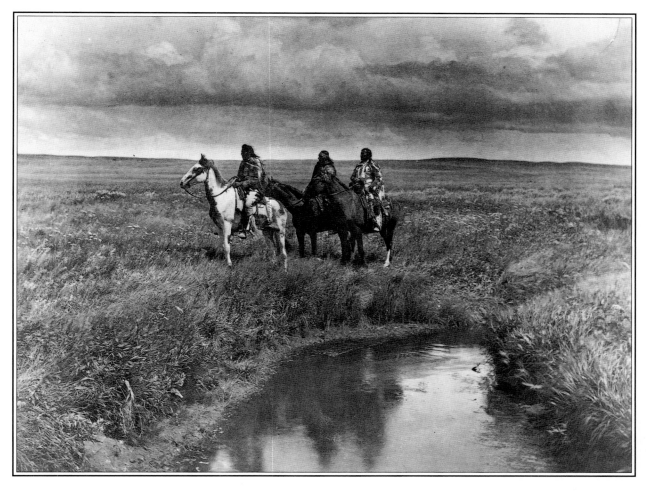

LEFT: *Three Chiefs, Piegan by Edward S. Curtis. Curtis spent 30 years photographing Native Americans.*

BELOW: *Frederic Remington at work in his studio. He was one of several artists who painted romantic images of the West.*

Bierstadt and Thomas Moran vividly evoked God's own country, far removed from the tamer eastern Hudson River School landscapes of Asher Brown Durand and others. The coming of the railroad hastened the demise of this ideal inviolate West. Now settlers came in a constant stream, encountering hostile tribes protective of their territory. This brought the cavalry and George Armstrong Custer, whose defeat at Little Big Horn tempered the nation's idealism about the West with a dash of realism. By the 1890s, after the battle of Wounded Knee, it was all over. While Chicago hosted the 1893 World's Columbian Exposition, historian Frederick Jackson Turner grandly announced, in his address to the American Historical Association, that the frontier was now closed. Meanwhile, on the Exposition's fairgrounds, the performers of Buffalo Bill's Wild West Show energetically reenacted, before an appreciative audience, the glory days now past.

Of all the artistic media re-creating and preserving the West, photography is valued most for its truth and accuracy, although these qualities are not always absolute either. During a century of remarkable inventions – where would we be today without the telephone, automobile, electric light, movies, sewing machine or bicycle – the camera was one that stood out as miraculous. Only the railroad was more publicized and certainly did more to change the quality of everyday life in the nineteenth century. It is no small historic coincidence that photography and the railroad were developed at about the same time, and served to document and facilitate the most intensive decades of westward expansion, the era of manifest destiny.

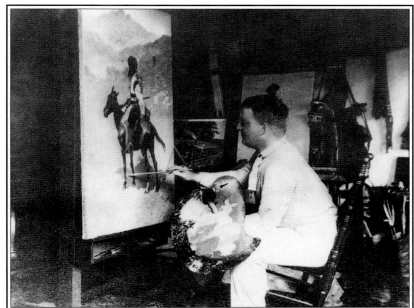

After its American introduction in 1839 by painter and telegraph inventor Samuel F. B. Morse, photography was to undergo considerable technological change before it became the useful instrument of landscape photography. While the earlier daguerreotype was capable of preserving exquisite detailed images on sensitized copper plates, the required exposure times were long, the images were fragile and relatively small, and each photograph was unique – there was no reproducible negative.

The daguerreotype, which was far more practical for portraiture than for landscape photography, was widely used until 1851, when the collodion process was developed. Collodion was a sticky fluid made of guncotton dissolved in alcohol and ether. Exposed to air and impermeable to water,

it dried quickly to a tough transparent film. Collodion was first used in 1848, medically, to protect wounds. It was discovered that glass plates coated with collodion could be exposed in a camera to make reproducible negatives. Because the entire process of exposing and developing the plate had to take place before the tacky collodion dried, this became known as the wet-plate process. Once the film was dry a protective coating was applied, and photographic contact prints could be made much later by using sunlight and laying the glass negative over sensitized paper.

As can be imagined, making photographs in the field and

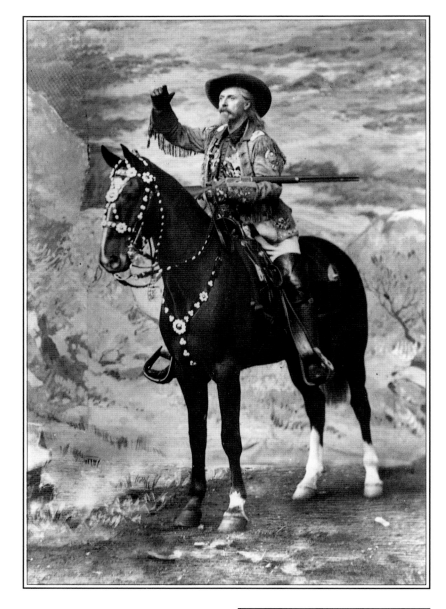

on the frontier by means of the wet-plate process was an arduous and inconvenient business. Bulky equipment – including cameras, heavy glass plates, chemicals, developing gear, and darkroom boxes or tents – could be transported in the Civil War ambulance wagons used by O'Sullivan and others. But the real test came when all this equipment, along with the water necessary for rinsing the plates, had to reach locations inaccessible by wagon – on horseback or human back.

The difficulty was alleviated to some degree, no doubt, by the photographers' sense of heroic mission. The accounts of hair-raising escapes from injury and death that come down to us are reminiscent of the adventures of Indiana Jones and other adventure movie heroes. Certainly a strong motive was the financial one. With the arrival of the reproducible negative, landscape photography now became a commercially viable enterprise. Multiple prints could be made from large and small negatives to be sold in album or portfolio form, or to be marketed individually in galleries to thousands of eager customers and collectors of all kinds. The most profitable of all were the stereographs, also made possible by the collodion process. The three-dimensional illusion of these images was produced by two separate views of the same subject taken from viewpoints two and a half inches apart, about the distance between the eyes. Twin-lens stereoscopic cameras were an essential part of the photographer's equipment. They were used in tandem with larger cameras to record highlights, unusual features and typical scenes of western landscapes, towns and people. Stereo pictures, mounted on cards and frequently issued in series format, were enormously popular and, along with special stereo viewers, were sold in the millions.

Landscape photography, distributed in stereographic guise, thus became a truly democratic art form. It is unlikely, though, that the photographers who risked their lives and fortunes to amass this indelible archive of western Americana were ever aware of how far their images would travel, over space and time, and to what uses they would be put. Probably they gained their greatest satisfaction simply from the making of good photographs.

ABOVE: *William F. Cody organized and then toured with Buffalo Bill's Wild West Show. The show's popularity reflected America's fascination with the West.*

RIGHT: *Samuel F.B. Morse introduced photography to America.*

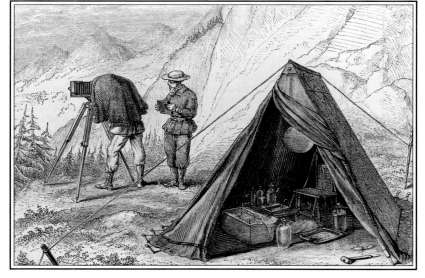

In the 1860s Carleton Watkins (1829–1916) earned universal critical acclaim for his artistically composed mammoth plate views of Yosemite. Born in Oneonta, New York, he traveled to California during the gold rush era, and in 1853 settled in San Francisco, where he learned photography in the studio of Robert Vance. His earliest landscapes were commissioned to provide evidence in land fraud cases. In 1861 Watkins opened his own studio for portraiture and a commercial clientele of businessmen, ranchers and mine owners. During the same year he made his first trip to Yosemite, and over the next few decades he returned at least eight times. He pioneered the use of the mammoth plate camera, expressly constructed to his specifications, that yielded 18-by-22-inch glass negatives. In 1866 he worked with surveyors Josiah Whitney and Clarence King in Yosemite, and in 1870 joined King again, when he led a California Geological Survey ascent of Mounts Shasta and Lassen. Some of his best work came from an 1868 trip northward up the Pacific Coast to Oregon. In 1873 Watkins journeyed to Utah to photograph along the Central Pacific Railroad route. During the financial panic of the mid-1870s, he lost his San Francisco gallery and a number of his negatives. This led him to re-photograph many locations in order to replenish his stock of landscape views. In 1880 he traveled southward for the first time, documenting Spanish missions along the Camino Real and following the Southern Pacific Railroad to Tucson, Arizona. Around this time he established a new San Francisco gallery to print and sell his mammoth plate and stereograph views. He continually enlarged his inventory by adding city views and images of life in the region. By 1890 his eyesight began to fail. Unfortunately, as an aftermath of the 1906 San Francisco earthquake, his studio burned and his prints and negatives were destroyed. In 1910 he was com-

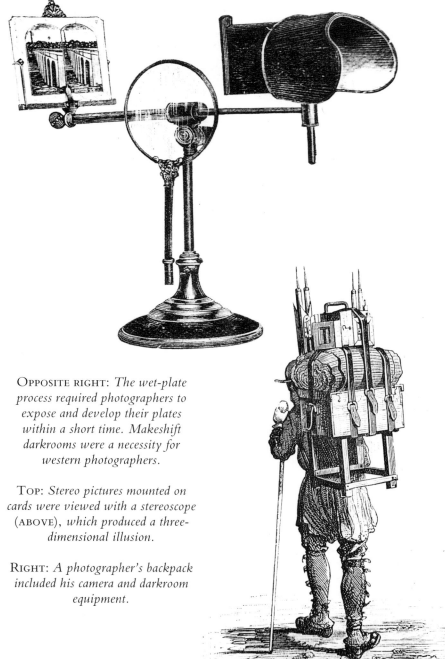

OPPOSITE RIGHT: *The wet-plate process required photographers to expose and develop their plates within a short time. Makeshift darkrooms were a necessity for western photographers.*

TOP: *Stereo pictures mounted on cards were viewed with a stereoscope* (ABOVE), *which produced a three-dimensional illusion.*

RIGHT: *A photographer's backpack included his camera and darkroom equipment.*

LEFT: *Carleton E. Watkins being led from his San Francisco gallery after the devastating earthquake in 1906.*

BOTTOM LEFT: *A photograph of Eadweard Muybridge.*

BOTTOM RIGHT: *Muybridge's 1878 study of the horse in motion. Taken at 27-inch intervals, these pictures illustrate the positions taken by a mare during a single stride.*

OPPOSITE TOP: *Andrew J. Russell's* Surveying Under Difficulties, *photographed during the Wheeler survey in 1869.*

mitted to an insane asylum where he spent his last years.

Eadweard Muybridge (1830-1904) is widely recognized today for his studies of animal and human movement, but during his long career, the years 1867 to 1873 were devoted to pioneering documentation of the West. Born Edward Muggeridge in England, he sailed to New York in the early 1850s and by 1855 was established as a bookseller in San Francisco. After returning from a prolonged trip to England in 1867, he began to photograph all aspects of California life – the architecture and waterfront of San Francisco, missions, vineyards, lighthouses, agriculture, industry and the Modoc Indian War. In 1868 he traveled as the photographer with the Halleck expedition to Alaska, and in 1875 to Central America for the Pacific Mail Steamship Company. International recognition first came with his dramatic landscape photographs of the Yosemite Valley, made on two separate trips. His first series of 72 Yosemite views taken in 1867, along with 114 card stereographs, was signed "Helios," probably as a protection against pirating of his work. In 1872 he made his last and most important group of landscapes, a series of 51 mammoth plate Yosemite views, widely praised for their artistic excellence. Muybridge was awarded a medal at the

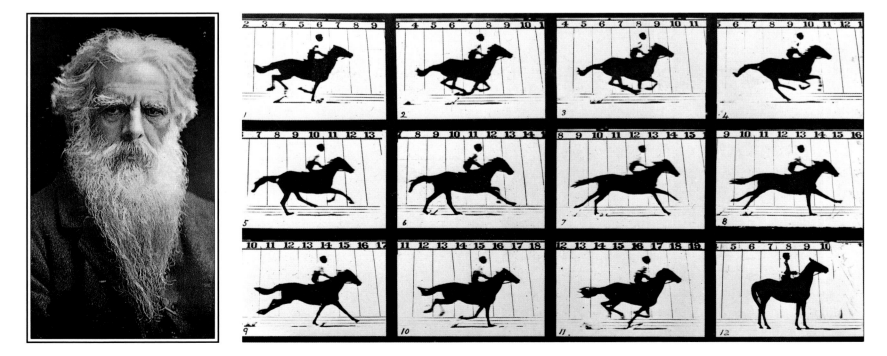

BOTTOM LEFT: *Muybridge's studies of animal motion forced artists to correct the horse's pose in their paintings from the flying gallop to the position seen here in Frederic Remington's* Buffalo Hunter at Full Gallop Loading His Gun with His Mouth.

LEFT: *A tintype of Andrew J. Russell.*

1873 Vienna international exposition. In order to settle an 1872 bet, California Governor Leland Stanford commissioned Muybridge to photograph his horse Occident trotting, to prove that all four hooves were off the ground at some point. The resulting scientific investigation was interrupted by Muybridge's temporary departure in 1875 after he killed his wife's lover, a crime of which he was acquitted. Using a battery of first 12 and then up to 24 cameras with mechanically tripped shutters, Muybridge was able to capture all stages of the horse's stride. In 1878 *The Horse in Motion* was published and brought him worldwide acclaim from scientists and artists alike. Confronted by this evidence, artists such as Frederic Remington ceased depicting horses in the conventional but inaccurate flying gallop. A year later Muybridge invented the forerunner of the motion picture projector, the zoopraxiscope, which projected the photographs in rapid succession, thus creating the illusion of movement. In 1884, with the assistance of painter Thomas Eakins, Muybridge moved his project to the University of Pennsylvania where he enlarged his area of study and published his most important work, *Animal Locomotion* (1887), containing over 100,000 images in 11 volumes. Muybridge returned to England in 1894 where his last book, *The Human Figure in Motion* (1901), was published.

For his most famous photograph of the most publicized event of nineteenth-century America, Andrew J. Russell (1830-1902) was present to record the May 1869 driving of the golden spike joining the transcontinental railroad at Promontory Point, Utah. Unfortunately, this widely reproduced image was long credited instead to Mormon photographer Charles R. Savage of Salt Lake City. Born in Nunda, New York, Russell started out as a painter of portraits, landscapes and panoramas. He served during the Civil War as a captain in the U.S. Military Railroad Construction Corps, officially assigned to photograph fortifications, buildings, troop transport equipment and the erection and dismantling of bridges and roads. After leaving the army in 1865, he was appointed the official photographer by the Union Pacific Railroad to document construction across Wyoming and

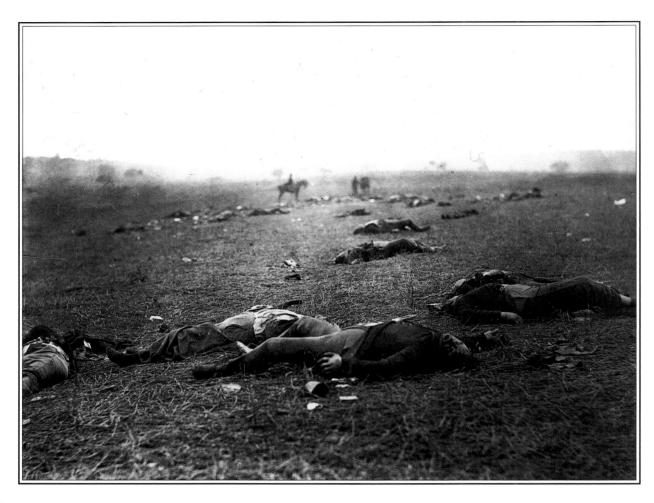

LEFT: *Timothy O'Sullivan's* Harvest of Death, *1863. O'Sullivan's Civil War experience would serve him well when he faced the arduous conditions of photographing in the West.*

BELOW: *O'Sullivan's* "Explorer's Column," *Spider Rock, Canyon de Chelly, Arizona, 1873.*

OPPOSITE: *William Henry Jackson's photograph* U.S. Geological Survey en Route, *1871.*

Utah. Russell also photographed the western landscape, geological formations, settlers and Native Americans along the route. He then briefly joined the King survey of the Bear River region of Utah. In 1869 the Union Pacific published *The Great West Illustrated in a Series of Photographic Views Across the Continent*, an album of 50 albumen prints of Russell's work. Ferdinand Hayden's *Sun Pictures of Rocky Mountain Scenery* (1870) also included a number of views by Russell. After completing a series of promotional views of the West for the railroad, he returned to the East to New York City where he established a studio.

Of all the landscapes from the heroic age of western photography, it is the work of Timothy O'Sullivan (1840-82) that appeals most to those moderns who regard the "beautiful" views of Carleton Watkins and others as sentimental and melodramatic. O'Sullivan was the son of Irish immigrants and was raised on Staten Island, New York. After training and working with Mathew Brady, he soon demonstrated an individualistic sensibility for realism, abstraction and unconventional composition in such Civil War images as his powerful *Harvest of Death*.

After working for Alexander Gardner, O'Sullivan went west to join Clarence King's Fortieth Parallel Expedition, which was to explore and survey along the proposed route of the Central Pacific Railroad. From 1867 to 1869, under conditions of extreme difficulty, O'Sullivan documented the mine shafts of the Comstock Lode; the tufa formations of Pyramid Lake; the inhospitable Humboldt and Carson sinks; the Ruby, Wasatch and Uinta mountains; Great Salt Lake basin; Shoshone Falls and the Green River. In 1870 he joined

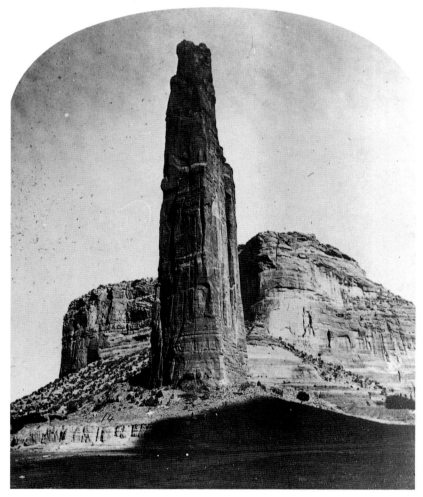

a U.S. Navy expedition searching for a canal route across the isthmus of Panama. He returned to the West in 1871 to join the Wheeler survey of Nevada and Utah, and this time O'Sullivan traversed Owens Valley, Death Valley and the Colorado River through the Grand Canyon. In 1872 he tem-

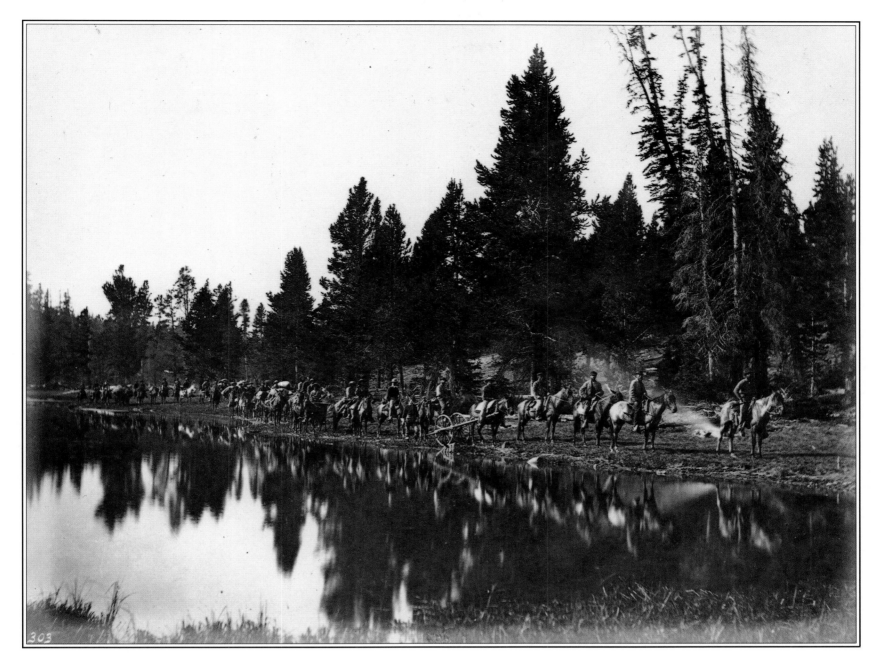

porarily rejoined the King survey in Utah and returned to the Green River Valley. In an independent 1873 expedition for Lt. George Wheeler, he traveled to the Southwest, visiting the Canyon de Chelly, and the Zuñi and Magia pueblos. In 1874-75 he went back to photograph more Southwestern cultures, including the Mojave and Navaho.

The years that followed were ones of hardship and deteriorating health as O'Sullivan returned to Washington to make photographic prints for the Wheeler survey album. Briefly in 1879 he worked as the photographer for the newly organized U.S. Geological Survey, and in 1880 was appointed the photographer for the Treasury Department. Tuberculosis forced him to resign and return to his father's house on Staten Island to die at the age of 42.

By far the most famous and commercially productive of all nineteenth-century photographers of the West was William Henry Jackson (1843-1942). This reputation was due in no small part to his vigorous self-promotion, although his spectacular views of the Yellowstone and Mammoth Hot Springs are memorable. Born in Keeseville, New York, he retouched photographs in various New England galleries before serving in the Civil War as a staff artist. A romantic

disappointment led to his decision to go west – part of the way as a teamster on an oxen-drawn wagon supply train – to seek adventure and fortune. In 1867 he and his brother started a photography studio in Omaha, the headquarters of the Union Pacific Railroad. There they made a living from portrait and architectural work.

In 1869 the restless Jackson learned landscape photography by trial and error as he trekked westward along the Union Pacific route as an itinerant photographer. After working as a volunteer in 1870, Jackson was appointed the official photographer for the Hayden Survey of the Territories, a position he held until 1879. The 1871 official expedition album, *Yellowstone's Scenic Wonders*, demonstrated Jackson's growing expertise. Sent to influential people in Washington, the publication resulted in renewed Congressional funding for the Hayden survey and in the 1872 establishment of Yellowstone as a national park. At the 1876 Philadelphia Centennial Exposition, Jackson exhibited his work, including his ethnographic images. He had made portraits of Native Americans around Omaha in 1868, and continued to document tribes and pueblos as a Hayden survey member.

In 1879, when the survey ended, he purchased his ex-

13

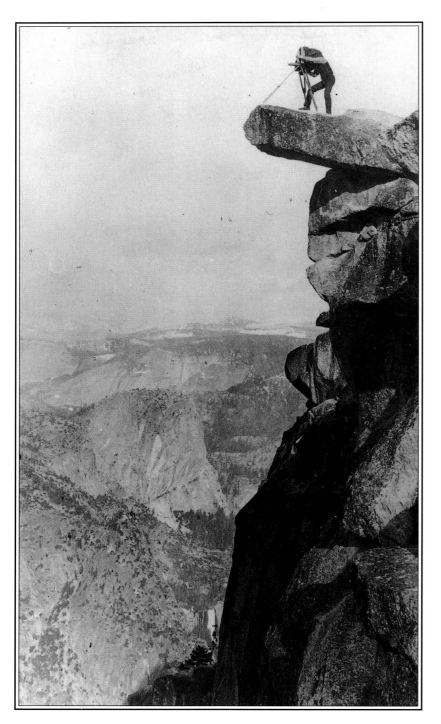

pedition equipment and started the Jackson Photographic Company in Denver, Colorado, to execute mammoth plate landscape and town views commissioned by railroads, and to distribute smaller images and stereographs of his expedition work. He continued to photograph and travel widely, and in 1894–95 documented an around-the-world trip for *Harper's Weekly*. As part-owner of the Detroit Publishing Company from 1897 to 1923, he oversaw the mass distribution of his photographs and their transformation into postcards. In the mid-1930s, when he was in his early nineties, Jackson painted four murals for the Department of the Interior representing the Hayden, King, Wheeler and Powell surveys. In 1938 he was adviser to the film *Gone With the Wind*, and in 1940 he published his lively autobiography, *Time Exposure*, based on his extensive diaries. Although he died in New York, Jackson is remembered in the West by the canyon and mountain named after him.

The reputation of Alexander Gardner (1821–82) is solidly based on his memorable Civil War photographs and por-

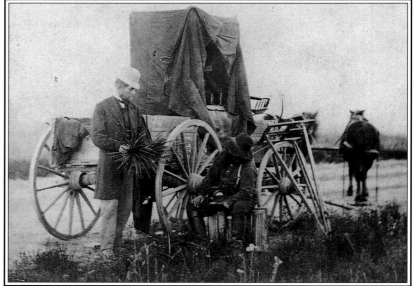

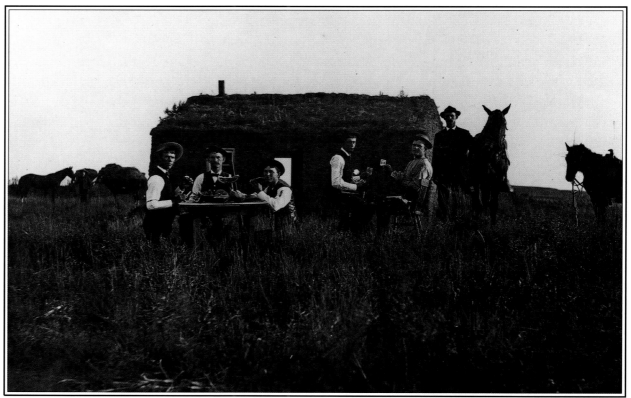

ABOVE: *A picture of William Henry Jackson photographing from the Rock at Glacier Point in Yosemite, California.*

RIGHT ABOVE: *Alexander Gardner standing near his horse-drawn photographic supply wagon.*

RIGHT: *Solomon D. Butcher's* Bachelor House of the Perry Brothers, near Merna, Nebraska, *1886.*

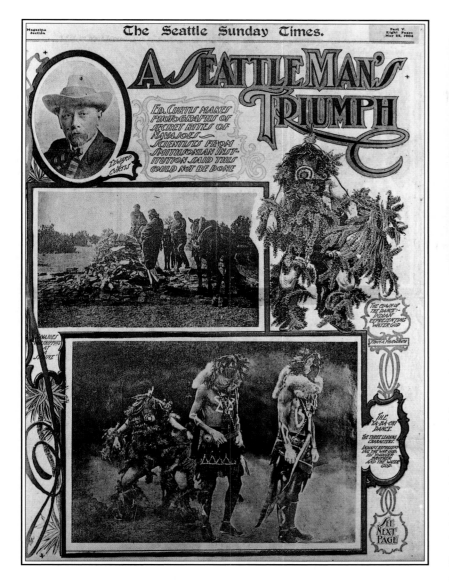

FAR LEFT: *A 1904 newspaper advertisement for Edward S. Curtis's photographs.*

LEFT: *A portrait of Edward S. Curtis taken in 1906.*

1880. From 1888 to 1900 Hillers headed the USGS photographic laboratory in Washington. Hillers's images of the Hopi and Pueblo people of New Mexico and Arizona helped to establish his reputation.

Solomon D. Butcher (1856-1927) – best known for his artless images of weather-beaten homesteading families arrayed with their possessions and animals in front of their sod houses and land claims – left a distinctive visual record of frontier life. Born in Burton, Virginia, he struggled financially for much of his life, variously as a traveling salesman, homesteader, medical student, postmaster, farmer, justice of the peace, land agent and enthusiast of get-rich-quick schemes. But it was as a photographer with a Custer County, Nebraska, studio, started in 1882, and later as an itinerant cameraman, that he left his mark. His *Pioneer History of Custer County, Nebraska* (1901), supported by sales of photographs and by subscriptions and donations, was the product of seven years of traveling around taking some 1,500 images on glass plate negatives and recording pioneer narratives. Later journeying to other western states, Butcher took pictures that were made into some 2.5 million postcards. By 1917 he abandoned photography, leaving an invaluable legacy of some 4,000 prints and glass plate negatives.

The most famous and controversial of the photographers of the Native American was Edward S. Curtis (1868-1952), a Wisconsin-born Seattle society photographer who early on had included Native Americans as figures in typically romantic soft-focus pictorialist landscapes. An 1899 trip to Alaska with the Harriman expedition persuaded Curtis of the importance of capturing on film the life and customs of the nation's tribal cultures west of the Mississippi before they inevitably disappeared. Beginning in 1900, this monumental project was to consume the next 30 years of his life as Curtis and a crew of assistants produced some 40,000 images of 80 tribes. The result was *The North American Indian*, 20 volumes of text and photogravures, accompanied by 20 photogravure portfolios. Costing $3,000 each, the undersubscribed series initially went to collectors and institutions. Curtis scrambled to find the funds to sustain the project and was lucky enough to obtain, through the support of President Theodore

traits of Abraham Lincoln. Born in Scotland, where he rose to the position of newspaper editor, Gardner sailed in 1856 to New York and was taken on as an assistant by Mathew Brady. After leading Brady's battlefield team of photographers for two years, Gardner started his own gallery following a dispute with Brady over the crediting of photographs. His two-volume *Gardner's Photographic Sketch Book of the War* (1866) combined text with 100 pictures by Gardner, Timothy O'Sullivan and others. In 1867 the Kansas Pacific and Union Pacific railroads hired Gardner as their official photographer to record the construction of the line from Kansas to Texas and California. On this assignment, he also documented the landscape, frontier life and Plains Indians. Back in his Washington studio in the 1870s, he made a series of portraits of tribal treaty delegates.

The unlikely beginning of the career as landscape and ethnographic photographer of John K. Hillers (1843-1925) occurred when he signed on as a boatman for John Wesley Powell's 1871 survey of the Grand Canyon. After saving Powell from drowning and helping expedition photographer E. O. Beaman, Hillers soon developed enough skill to be taken on as the official photographer when Beaman left. Previously, the German-born Hillers had worked as a Brooklyn policeman and served in the Civil War. He continued to make landscape and ethnographic photographs for Powell, who became head of the U. S. Geological Survey in

RIGHT: *Adam Clark Vroman's*
Mission, Pojoaque Pueblo, *1899.*

BELOW: Navaho Covered
Wagon *by Laura Gilpin, 1934.*

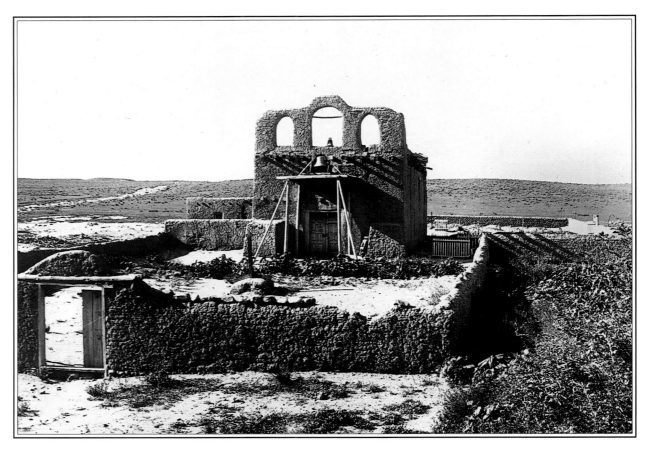

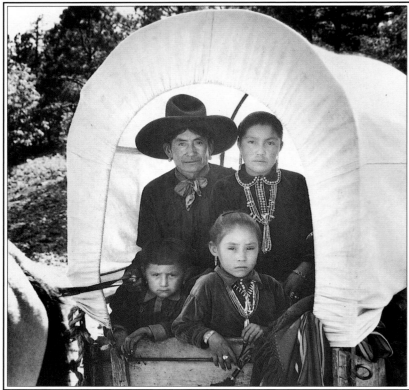

Roosevelt, the patronage of J. P. Morgan and company. Curtis approached his task with enthusiasm and dedication. He participated in rituals and studied the languages and religions of his subjects, making more than 10,000 recordings of Native American songs and stories on early Edison wax phonographic cylinders. As early as 1906 he used motion picture film to record parts of ceremonies.

The initial volumes of his work were well received, but a dissenting view was voiced by anthropologist Franz Boas who criticized the theatricality and inaccuracies of the photographs and cited the patronizing attitude of Curtis toward his subjects. It is true that Curtis manipulated both the ex-

posures and prints, subordinating scientific objectivity to artistic expression. He was known to have provided costumes, props and even long-haired wigs for his sitters so that he could portray the Noble Savage as he existed before the coming of the white man. Artifacts of modern life were scratched out of his negatives as well. While the photographs are not accurate ethnographically, they have been widely appreciated, especially in recent decades, for their mythic romanticism and evocative spirituality – an aesthetic effect arrived at by deliberate stylistic manipulation. By the time the project ended in 1930, Curtis had fallen into obscurity. His work would be rediscovered in the late 1960s.

A sympathetic recorder of the daily life and ceremonies of the Hopi, Zuñi, Navaho, Laguna and Acoma peoples, Adam Clark Vroman (1856-1916) was born in Illinois and worked there as a railroad agent before moving to Pasadena, California, in 1892 to open a bookstore. Following his first trip to the Southwest in 1895, Vroman spent some 15 years photographing Native Americans and the archaeological remains of their ancestors' dwellings. A collector of Indian artifacts, Japanese netsuke and fine books, he also traveled widely in Asia and Europe.

Remarkable as a pioneering woman landscape photographer of the West, Laura Gilpin (1891-1979) also is acclaimed for her sensitive photography of Southwestern cultures. Born on the family ranch in Austin Bluffs, Colorado, she was distantly related through her father to William Henry Jackson, who once photographed Frank Gilpin as a typical cowboy. Laura Gilpin, who received a Brownie camera for her 12th birthday, attended eastern boarding schools and, briefly, the New England Conservatory of Music. Encouraged by Gertrude Käsebier, she studied (1916-17) at the

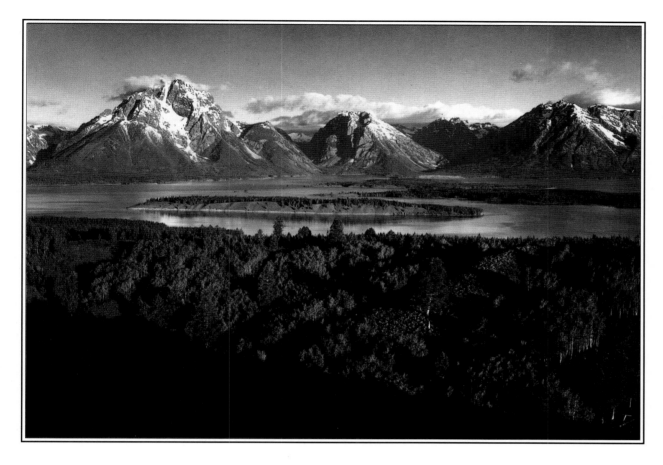

Clarence H. White School of Photography in New York. Initially recognized for her portrait work in a soft-focus pictorialist style and for her expertise in platinum printing, Gilpin returned to Colorado Springs to support herself with commercial assignments, architectural photography, and the production of tourist brochures, slide sets and postcards. During the early 1920s she started to explore Colorado and New Mexico on camping trips, which were to continue throughout her life. In 1946 she moved to New Mexico and her empathetic documentation of the native peoples and their environment resulted in four major books: *The Pueblo: A Camera Chronicle* (1941), *Temples in Yucatan: A Camera Chronicle of Chichen Itza* (1948), *The Rio Grande: River of Destiny* (1949) and *The Enduring Navaho* (1968).

The twentieth-century reincarnation of the great nineteenth-century landscape photographers, Ansel Adams (1902-84), unlike his predecessors, was born in the West, in San Francisco. Adams's first visit, in 1916, to the Yosemite Valley, decisively shaped his life. He returned yearly to explore and photograph, at first in a soft-focus pictorialist style. After he took over his father-in-law's photography studio there in 1936, Adams and his family lived in Yosemite until 1962. He became the official photographer for the Sierra Club in 1928, after years of leading mountaineering trips for the conservationist organization. His 1930 decision to dedicate his life to photography, instead of piano and music, came from a trip to Taos, New Mexico, where he met a number of modernist artists, among them painter Georgia O'Keeffe and photographer Paul Strand. Strand's abstracted sharp-focus images in the style known as "straight" photography influenced Adams's search for technical perfection in his own work, achieved through absolute control of the ex-posure, developing and printing processes. In 1932 Adams, Edward Weston, and other California photographers founded Group f/64, a progressive informal association dedicated to "pure" or unmanipulated realistic photography. Increasing recognition led to shows by Adams at the Smithsonian Institution and at Alfred Stieglitz's New York gallery, An American Place, in 1936, and to publication of his work in portfolio and book form, beginning with *Parmelian Prints of the High Sierras* (1927), *Taos Pueblo* (1930), *Sierra Nevada: The John Muir Trail* (1938), and the 1944 work *Born Free and Equal*, which examined the wartime life of Japanese-Americans interned at Manzanar camp. A 1936 trip to Washington to lobby for the establishment of a national park at King's River Canyon later brought the 1941-42 mural project commission from the Department of the Interior to photograph western national parks and Indian reservations. In 1940 Adams helped as advisor to organize the Museum of Modern Art's Department of Photography. In the 1940s teaching became an important aspect of his photographic pursuits, and various technical books on the subject followed. The Ansel Adams Workshops, teaching photography by using his Zone System, based on the previsualization of the final print, continued for decades, first in Yosemite and later in Carmel, California. In 1967 Adams founded The Friends of Photography, a nonprofit group to advance creative photography. The Presidential Medal of Freedom in 1979 honored his reputation as the greatest living American photographer, his environmental activism and, not least, his lifelong photographic exploration of the spiritually healing power of nature. But perhaps the most enduring accolade was the 1985 designation of Mount Ansel Adams in Yosemite.

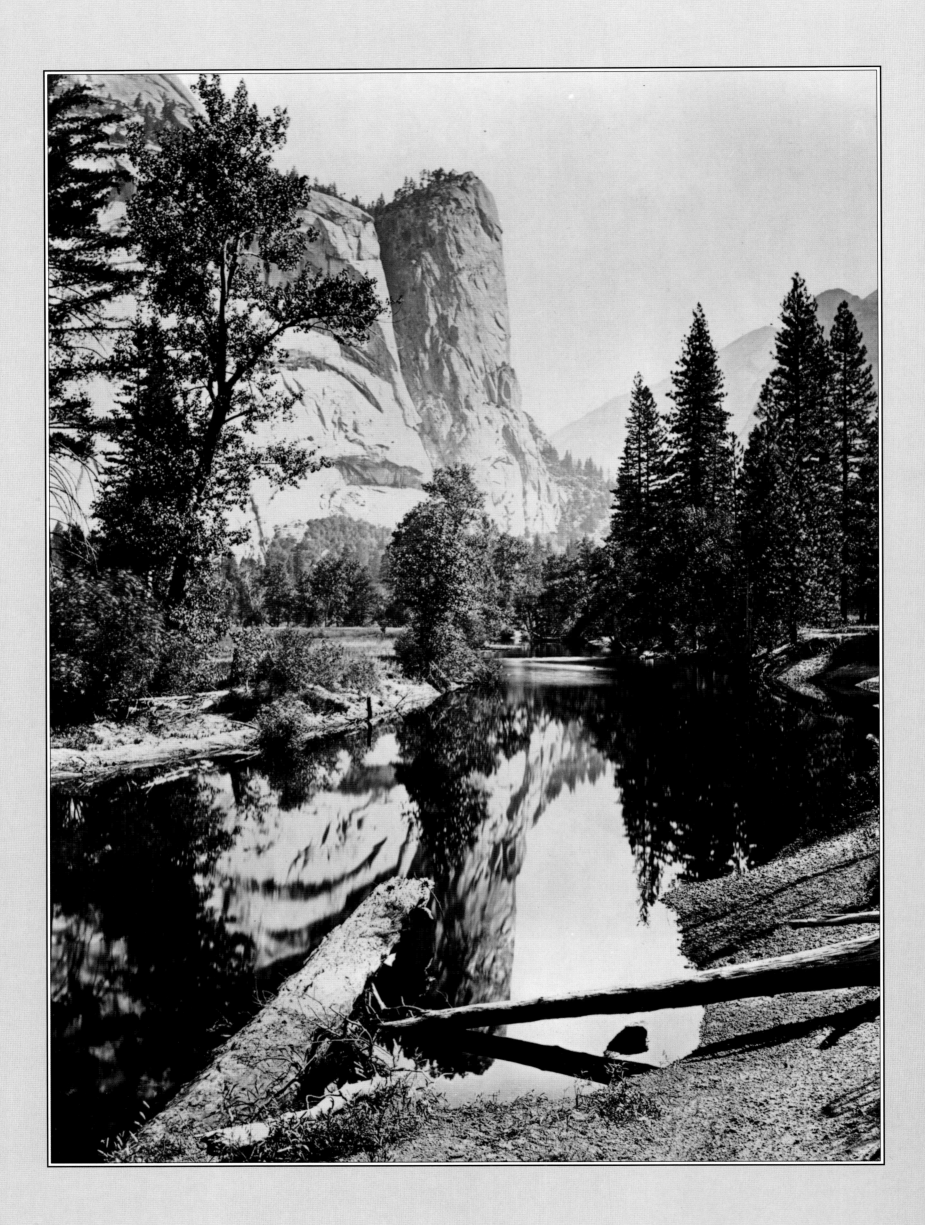

ARTISTIC VISIONS

Over the course of the nineteenth century, for Americans the magnificent western landscape became emblematic of their highest aesthetic ideals, their deepest religious convictions and their ambitious nationalist aspirations. This focus on nature and landscape was part of the larger Romantic movement, which saw nature as the source of man's knowledge and inspiration. Nature was the mind of God made visible and the embodiment of man's freedom. The West's uniquely American landscape at its most beautiful was seen as an earthly paradise, a latter-day Garden of Eden, and at its most dramatic, as evidence of God's handiwork. While architectural monuments marked the height of European civilization, America possessed equally splendid and ancient monuments in her primeval forests, awesome mountains and pellucid lakes.

These ideas were first explored in landscape painting by the artists of the Hudson River School, among them Thomas Cole and Asher Brown Durand. With the far more spectacular western landscape paintings by Albert Bierstadt and Thomas Moran, the Hudson River School's picturesque aesthetic of serene contemplation and worship of a more pastoral nature was transformed into the aesthetic of the sublime. The sublime, which emphasized soaring peaks, plunging precipices and stormy skies invoked in viewers overwhelming feelings of awe, confusion and terror. The experience of solitude and vastness also informed the sublime.

The earliest mammoth plate views by Carleton Watkins of the Yosemite Valley established the standard by which all later western landscape photography came to be measured. These remarkable images incorporated the motifs and conventions of picturesque landscape painting in formally balanced compositions that expressed the theme of classic harmony in an ideally pristine and peaceful nature. Although Watkins was acquainted with Bierstadt and was a close friend of William Keith, it is not clear whether he was aesthetically influenced by these painters. Possibly they gained more from him, as both at various times used Watkins's photographs as models for their paintings.

Deliberate competition with Watkins motivated the more dramatic Yosemite photographs of Eadweard Muybridge. To differentiate his own work, Muybridge employed stylistic devices of the sublime, emphasizing extremes of point of view, lighting effects, shape and distance. In his characteristic exploration of the paradoxes rather than the harmonies of nature, he occasionally sacrificed truth to nature – he was not averse to chopping down brush to clear a desired view, or to adding clouds to an image from a second negative. Reportedly Muybridge did accept aesthetic advice from Bierstadt on how to achieve certain pictorial effects and on taking views useful to studio painters. Both shared a predilection for the flamboyant and transient aspects of nature.

William Henry Jackson, who photographed Yosemite on mammoth plates after 1880 in tribute to the pioneering work of Watkins and Muybridge, developed his personal aesthetic vision while a survey photographer on the Hayden expedition. There he associated closely with the painters Sanford Gifford and Thomas Moran. According to Jackson's biography, he learned much from Moran who helped him to "solve many problems of composition." Moran later was to use some of Jackson's photographs of Yellowstone as studies for his paintings. Jackson's most publicized photograph, and probably the most famous western landscape photograph of the nineteenth century, was hailed less for its compositional expertise than for its nationalist and religious symbolism. The 1873 image of the legendary *Mountain of the Holy Cross* was captured by Jackson after a dangerous ascent in the Colorado Rockies. To a country still recovering from the Civil War and seeking affirmation of its destiny as a chosen nation, the peak with its great cross of snow seemed a visible revelation of God's blessing.

By the mid-1880s, this first golden age of landscape photography had come to an end. Less artistically inclined photographers flooded the market with inexpensive images of sites accessible to tourists, who bought them as souvenirs. High-quality photographs of unfamiliar sites far from the reach of the railroad were no longer in demand. Watkins eventually died a bankrupt and Muybridge had moved on to his experiments with animal locomotion. Only the latecomer Jackson was able to make a financial success of his landscape work. He continued to add to his archive of negatives, and adapted to changing times by cropping his western views for publication as postcards. Decades later, the idea of the spectacular western landscape as an artistically satisfying and spiritually moving subject was revived in the work of Ansel Adams.

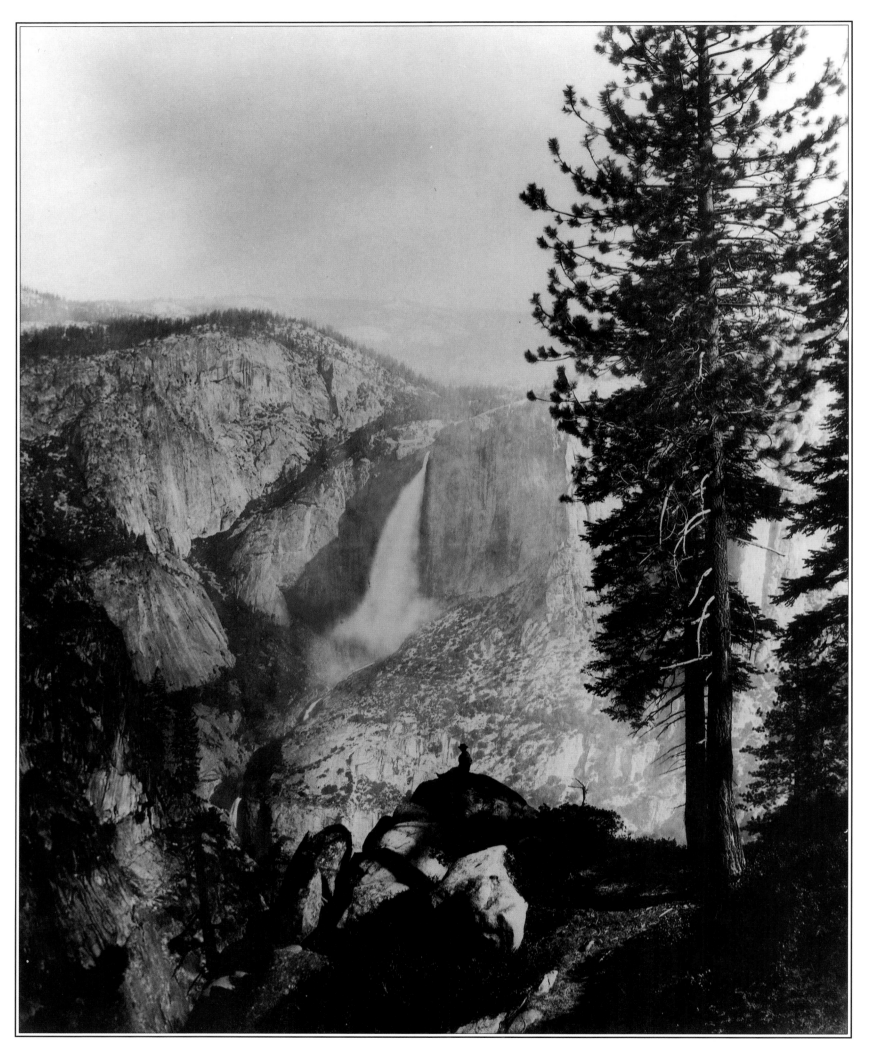

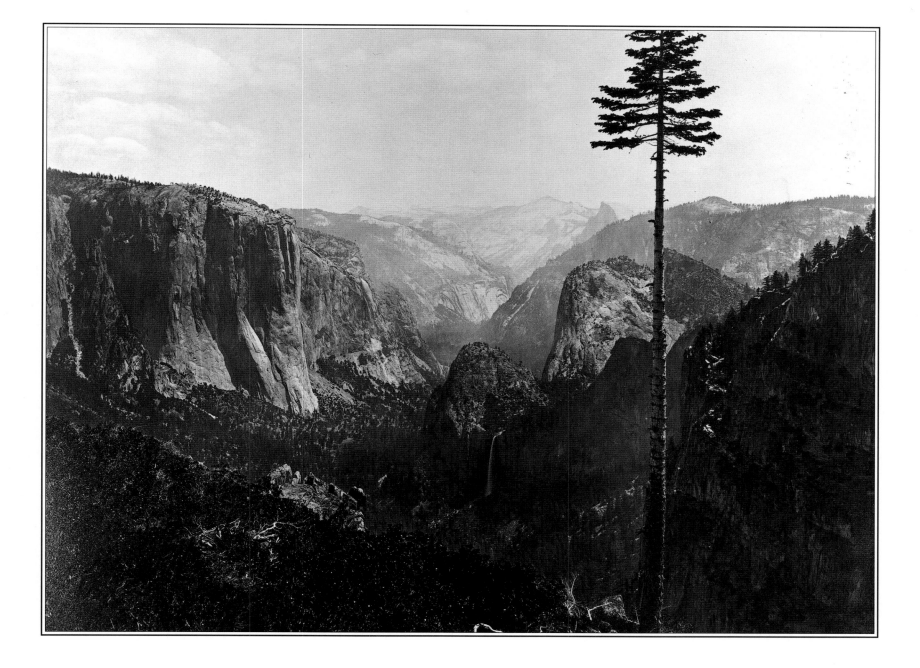

LEFT:
Eadweard Muybridge
Falls of the Yosemite from Glacier Rock, No. 36

DEPARTMENT OF SPECIAL COLLECTIONS
UCLA, UNIVERSITY RESEARCH LIBRARY
LOS ANGELES, CA

Carleton E. Watkins
Yosemite Valley from the Best General View
No. 2, 1866

AMERICAN GEOGRAPHICAL SOCIETY COLLECTION
UNIVERSITY OF WISCONSIN, MILWAUKEE, WI

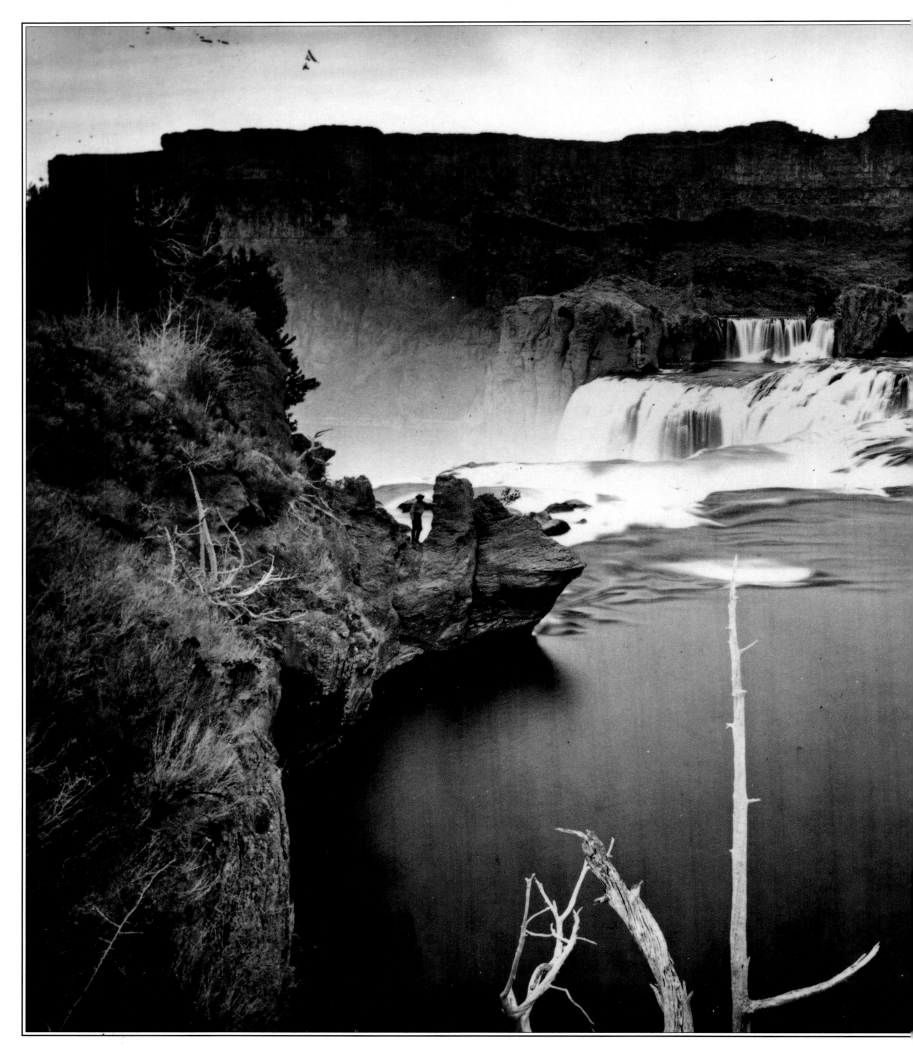

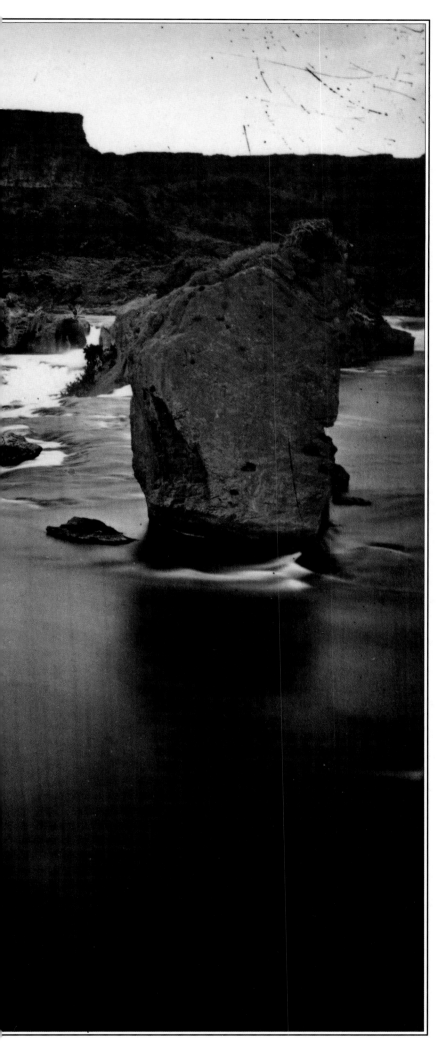

Timothy O'Sullivan
Shoshone Falls, Snake River, Idaho
(Wheeler Survey)

NATIONAL ARCHIVES
WASHINGTON, D.C.

Andrew J. Russell
Summit of Mount Hoffman, Yosemite, California

PHOTO ARCHIVES, MUSEUM OF NEW MEXICO

SANTA FE, NM

RIGHT:
William Henry Jackson
Grand Canyon of the Yellowstone River, 1872
Yellowstone, Wyoming

PHOTO ARCHIVES, MUSEUM OF NEW MEXICO

SANTA FE, NM

OVERLEAF:
William Henry Jackson
Mountain of the Holy Cross, Colorado, 1873

BEINECKE RARE BOOK AND MANUSCRIPT LIBRARY

YALE UNIVERSITY, NEW HAVEN, CT

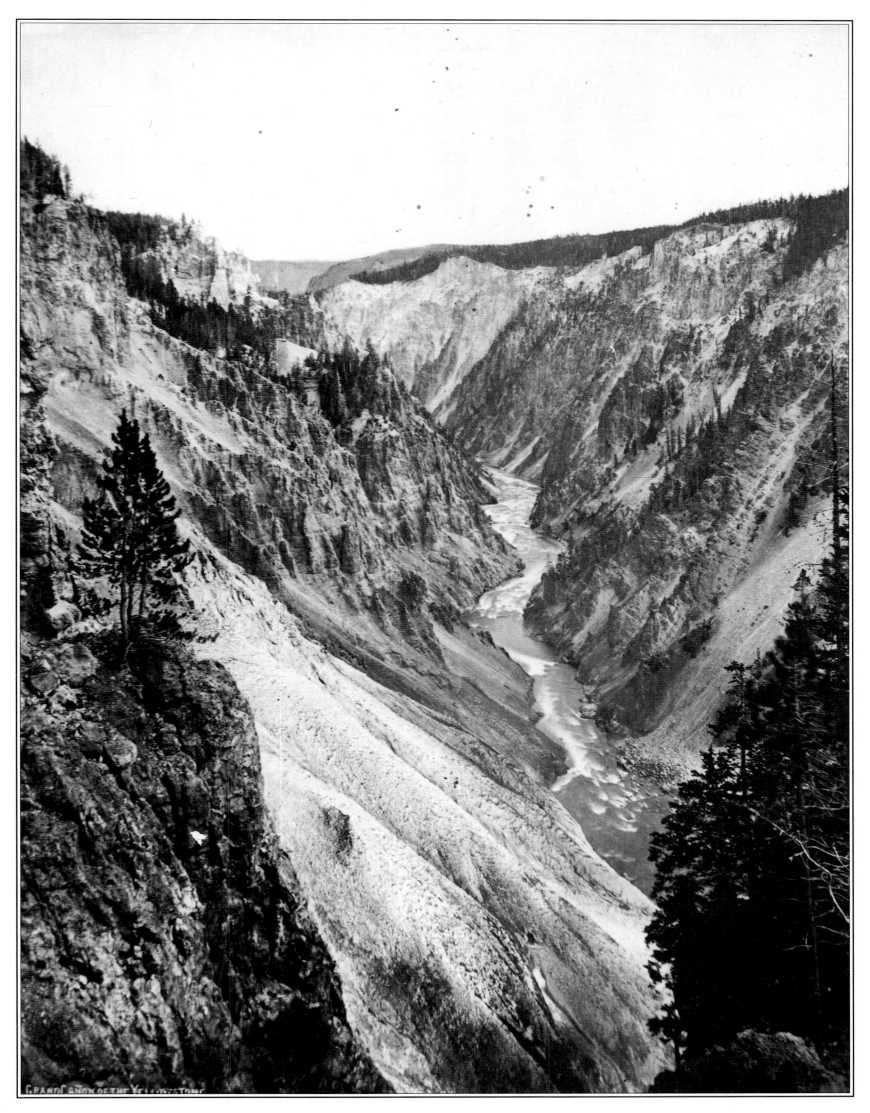

GRAND CANON OF THE YELLOWSTONE

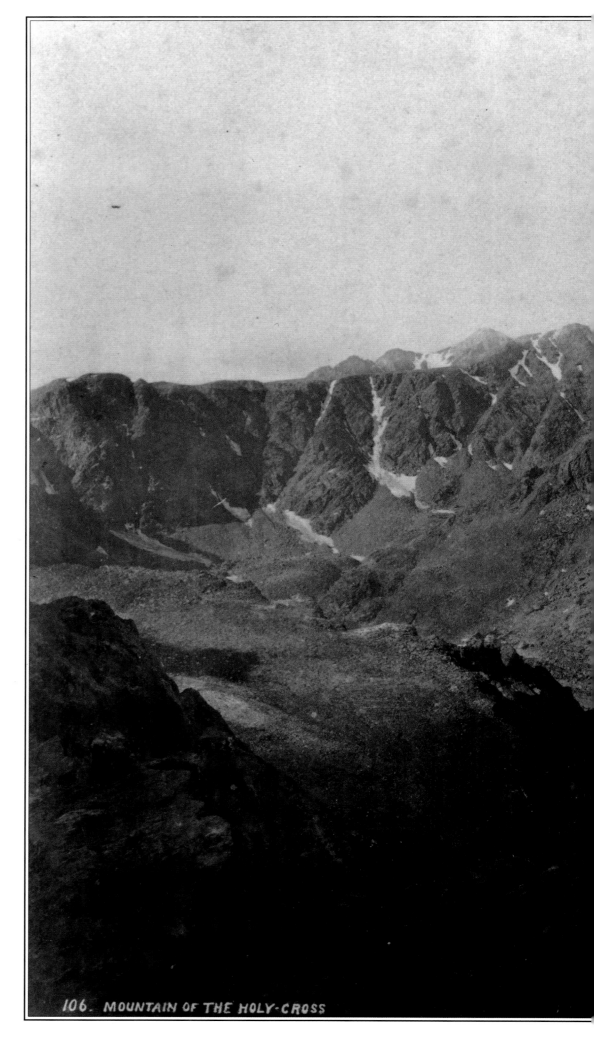

106. MOUNTAIN OF THE HOLY-CROSS

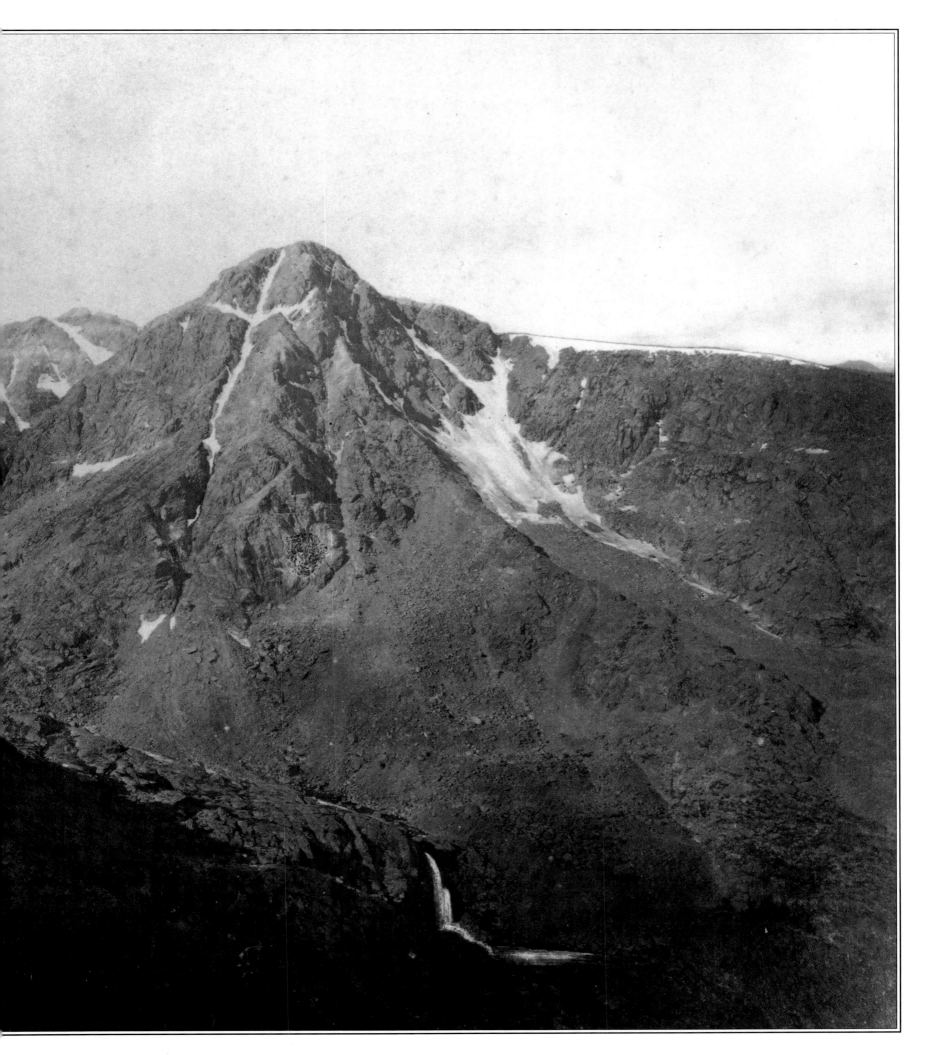

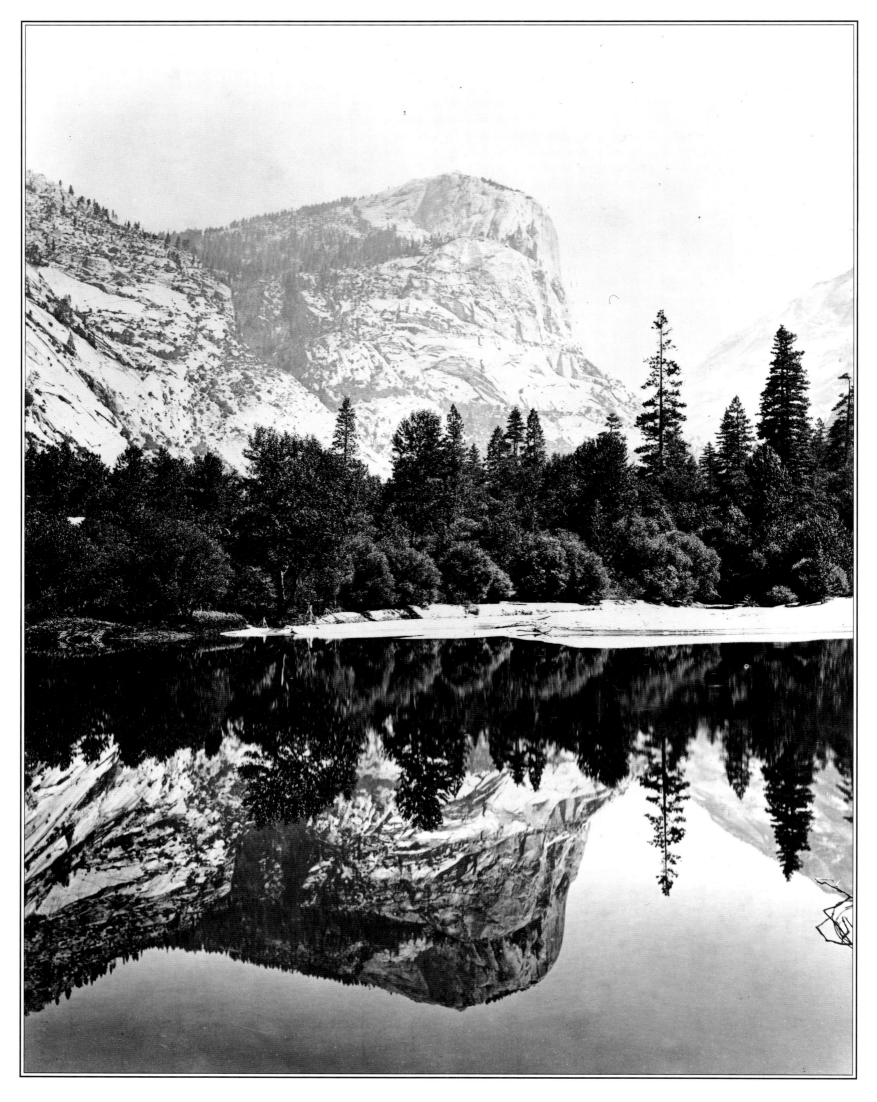

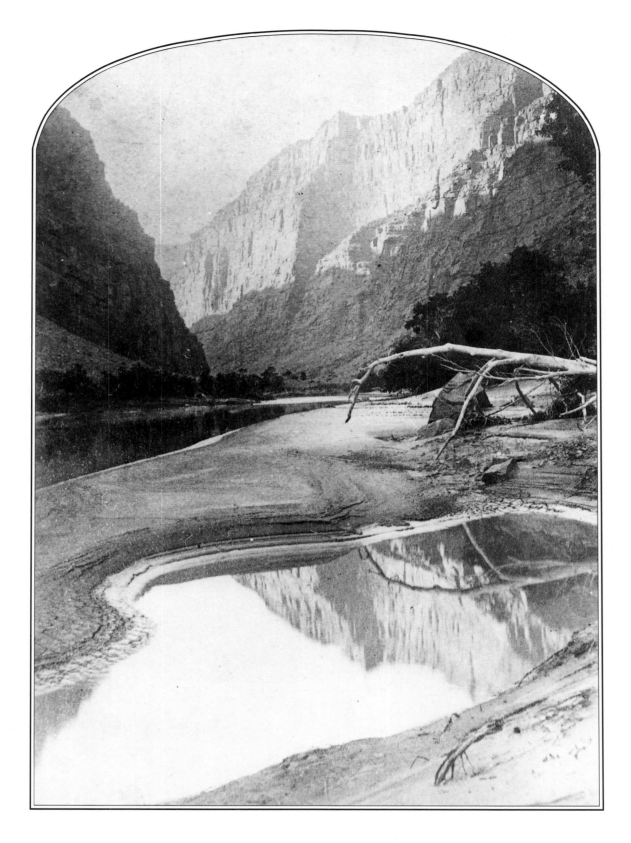

LEFT:
Carleton E. Watkins
Mirror Lake, Yosemite, No. 75, 1878

RARE BOOK DEPARTMENT, HISTORICAL PHOTOGRAPHS

THE HUNTINGTON LIBRARY, SAN MARINO, CA

John K. Hillers
Reflected Cliff, Green River, Ladore Canyon, Utah

PHOTO ARCHIVES, MUSEUM OF NEW MEXICO

SANTA FE, NM

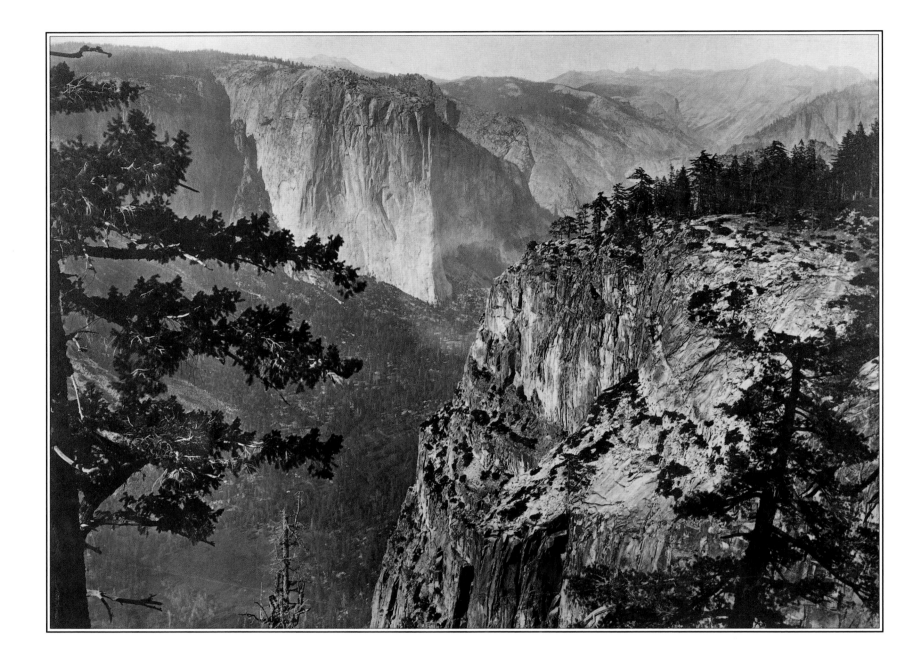

Carleton E. Watkins
First View of the Yosemite Valley,
from the Mariposa Trail, c. 1866

PRINTS DIVISION, BOSTON PUBLIC LIBRARY

BOSTON, MA

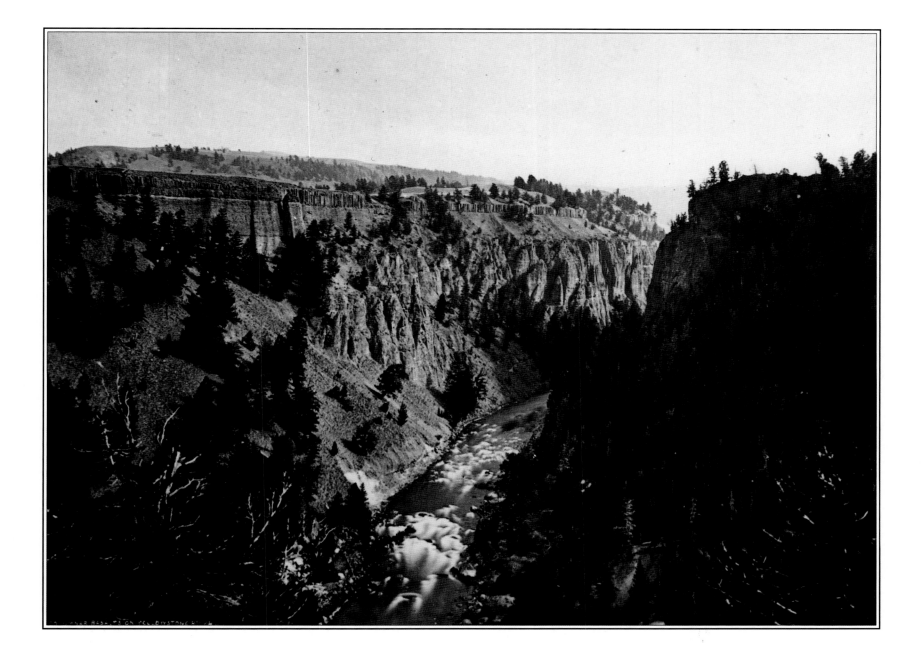

William Henry Jackson
Columnar Basalts on the Yellowstone River, 1874

PHOTO ARCHIVES, MUSEUM OF NEW MEXICO

SANTA FE, NM

OVERLEAF:
Ansel Adams
Evening, McDonald Lake,
Glacier National Park, Montana

NATIONAL ARCHIVES

WASHINGTON, D.C.

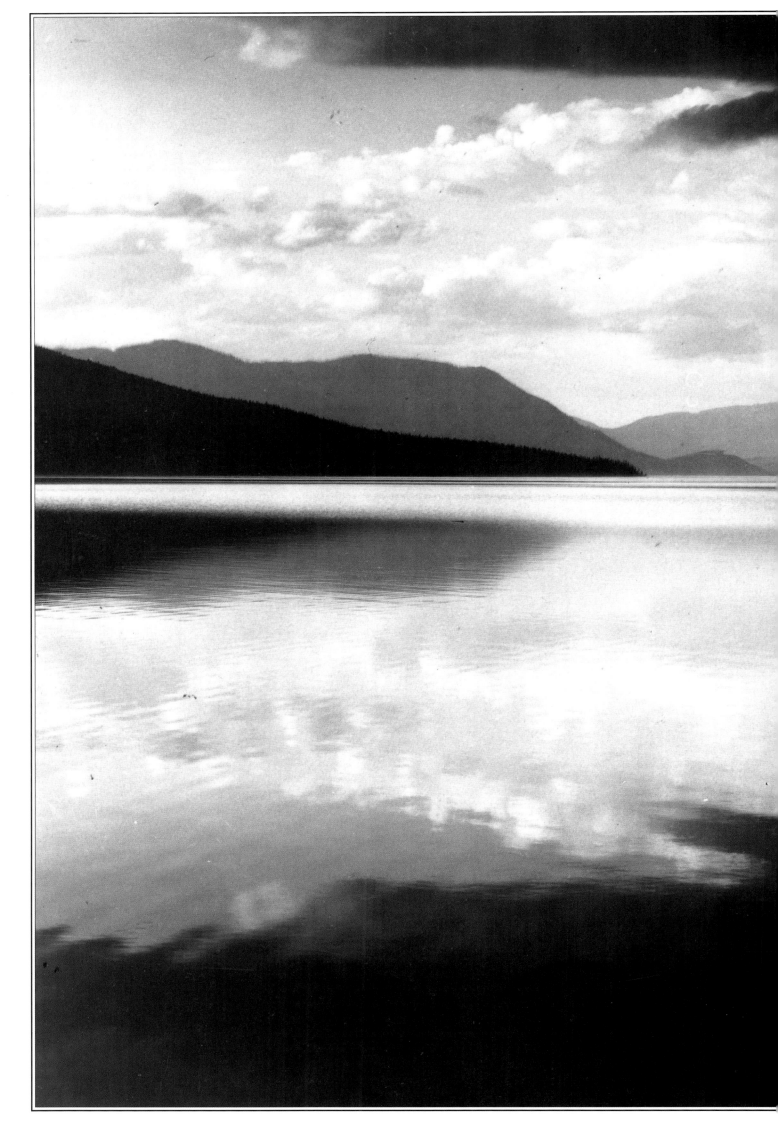

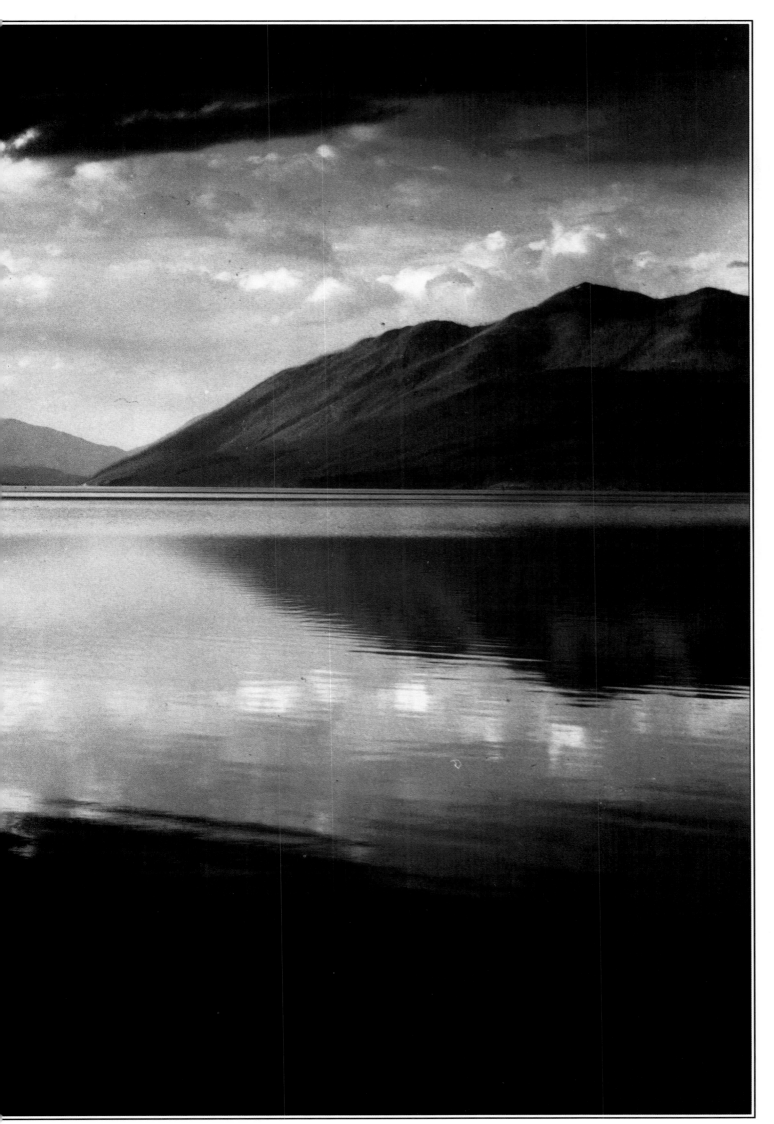

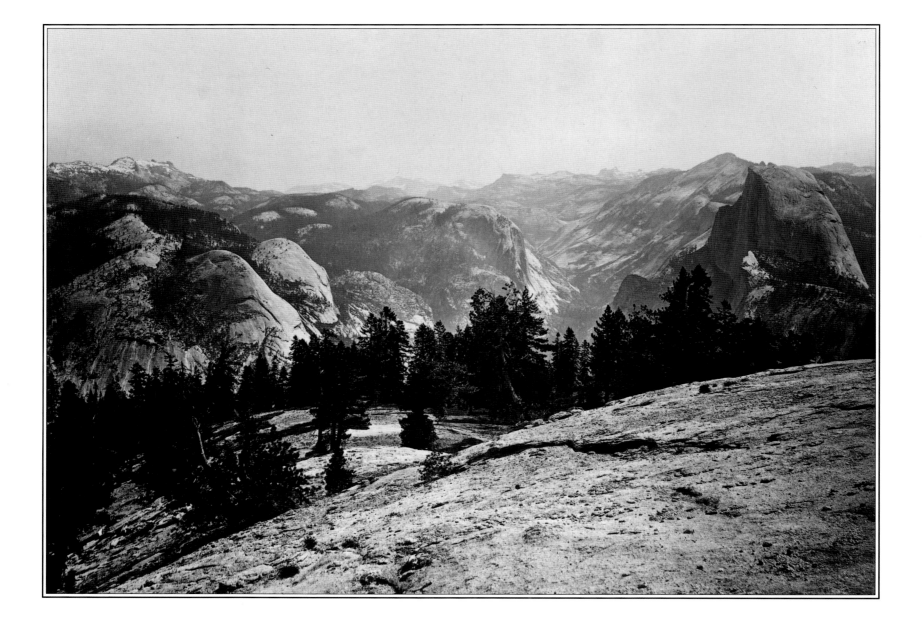

Carleton E. Watkins
The Domes from Sentinel Dome, Yosemite, No. 94, 1866

RARE BOOK DEPARTMENT, HISTORICAL PHOTOGRAPHS

THE HUNTINGTON LIBRARY, SAN MARINO, CA

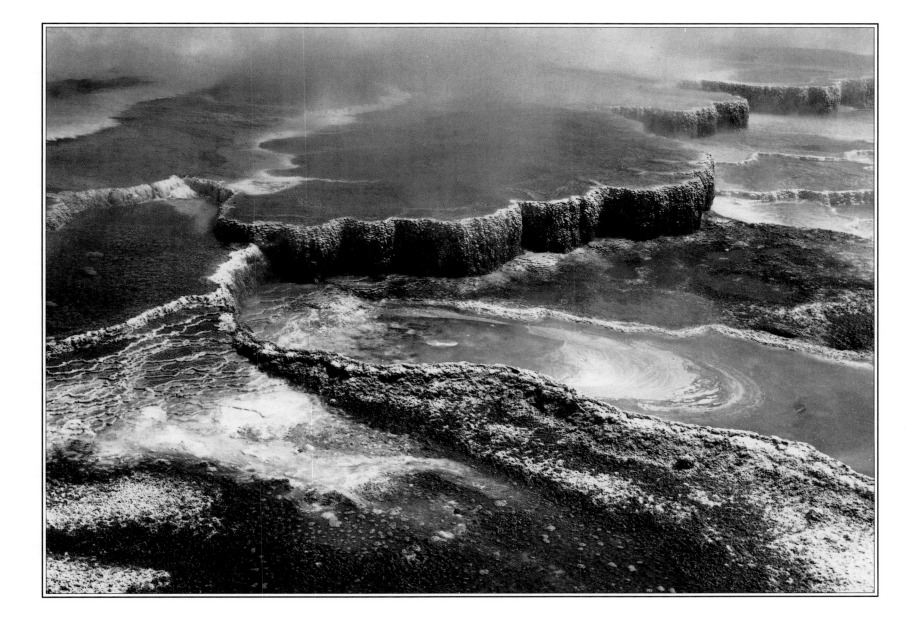

Ansel Adams
Jupiter Terrace–Fountain Geyser Pool
Yellowstone National Park, Wyoming

NATIONAL ARCHIVES

WASHINGTON, D.C.

Ansel Adams
Grand Canyon from South Rim, 1941
Grand Canyon National Park,
Arizona

NATIONAL ARCHIVES
WASHINGTON, D.C.

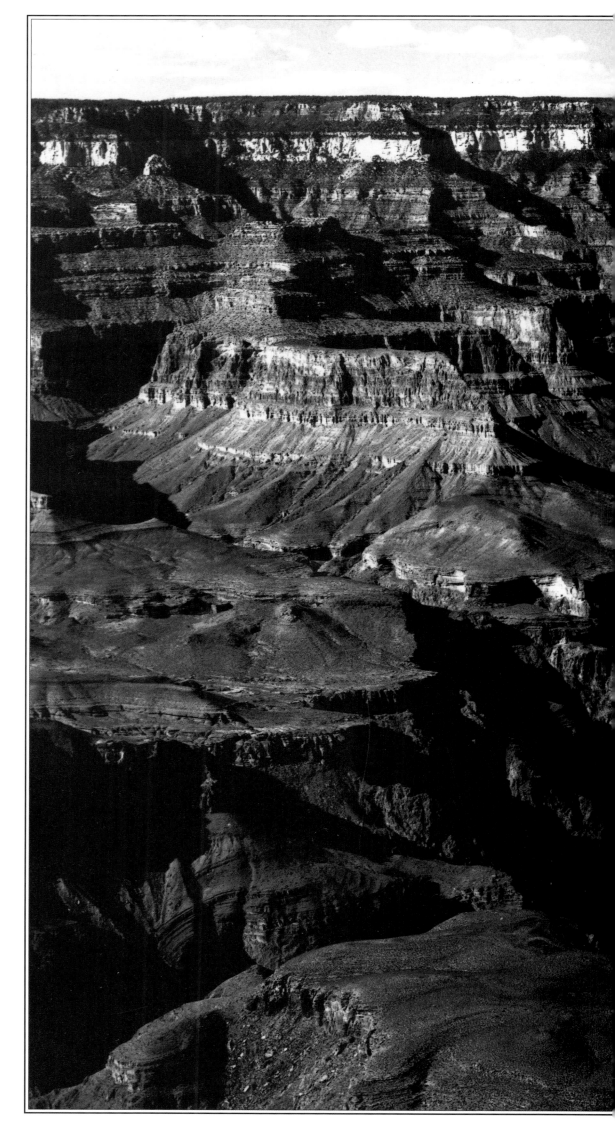

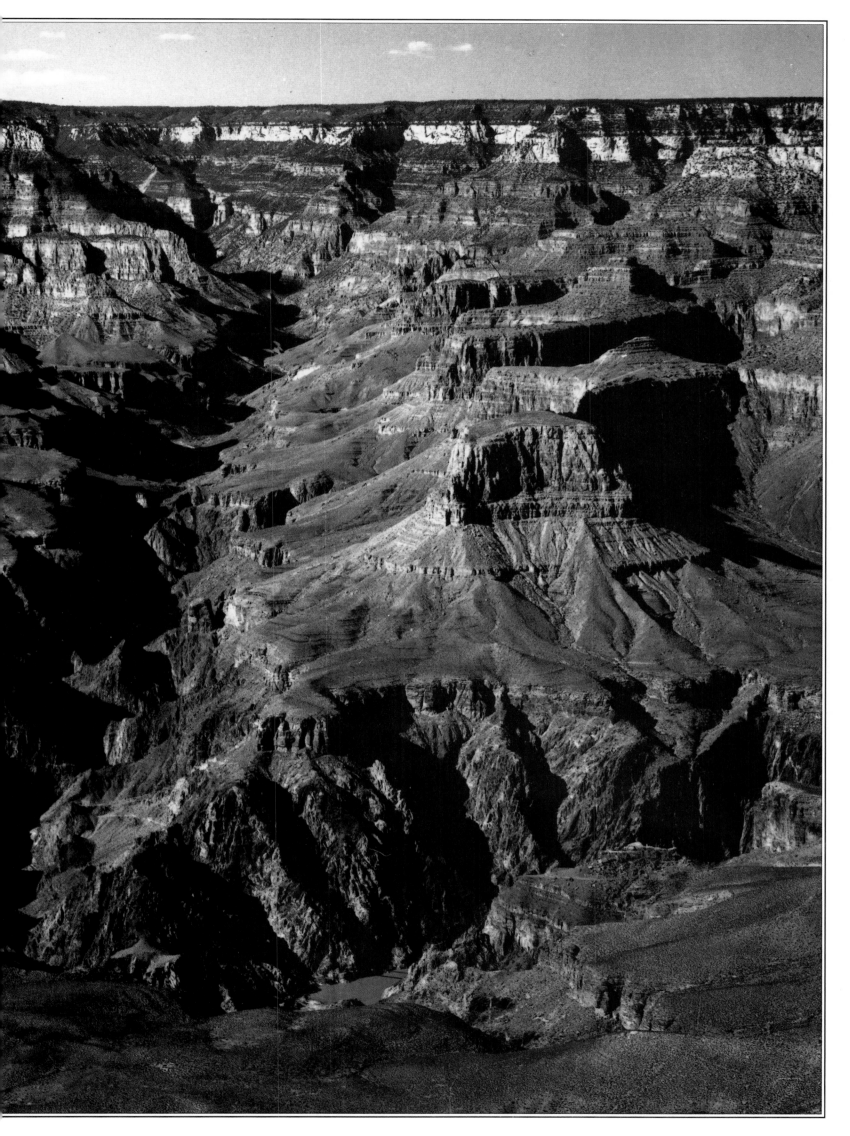

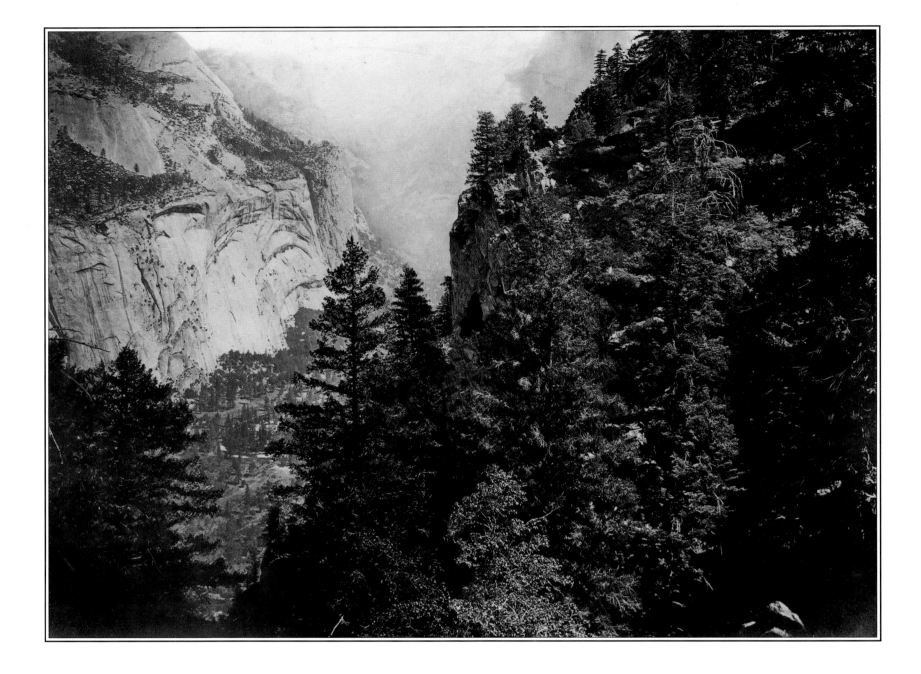

Eadweard Muybridge
Tenaya Canyon, Valley of the Yosemite, No. 35, 1872

DEPARTMENT OF SPECIAL COLLECTIONS

UCLA, UNIVERSITY RESEARCH LIBRARY, LOS ANGELES, CA

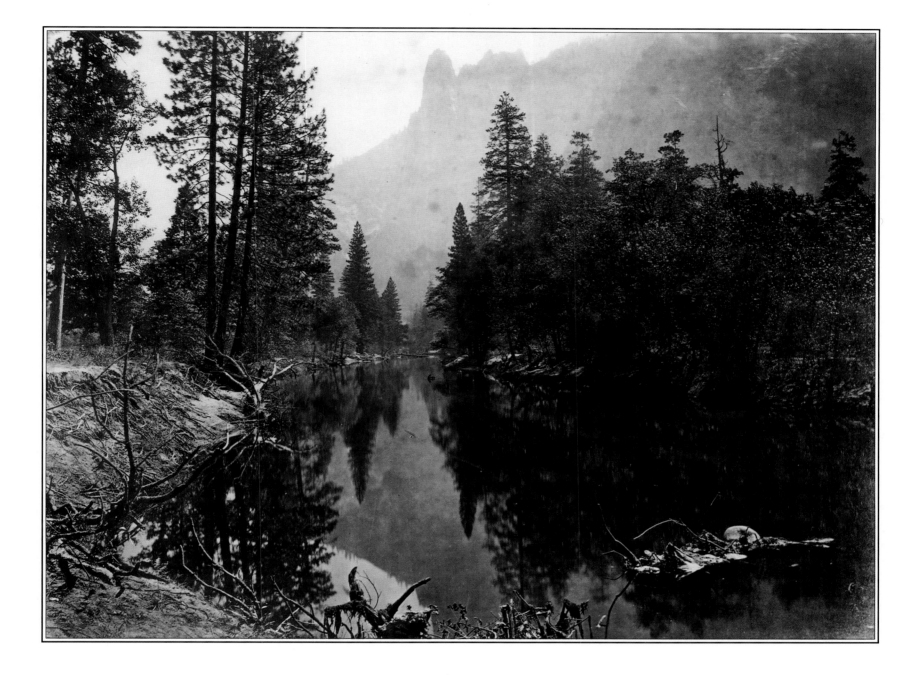

Eadweard Muybridge
Loya, Valley of Yosemite, No. 14, 1872

DEPARTMENT OF SPECIAL COLLECTIONS
UCLA, UNIVERSITY RESEARCH LIBRARY, LOS ANGELES, CA

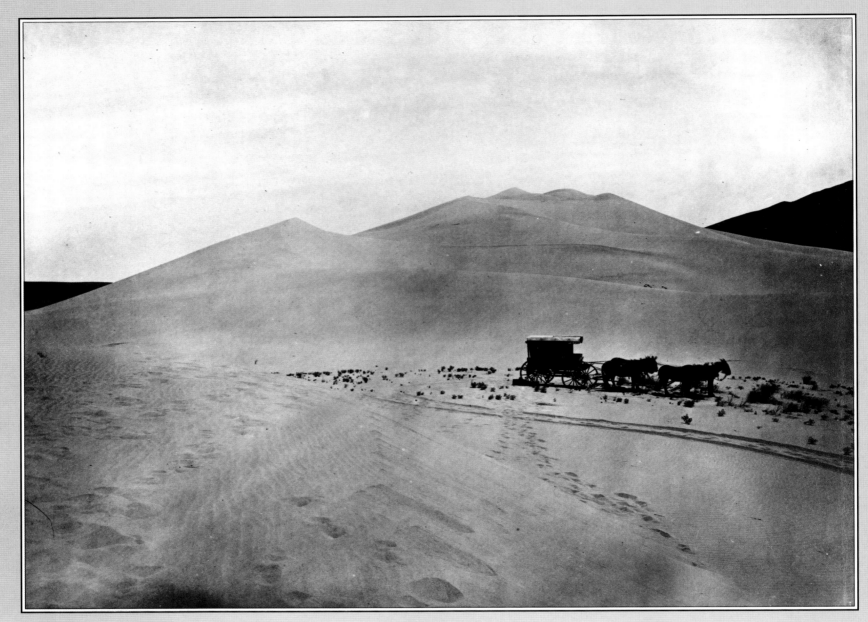

SCIENTIFIC EXPLORATIONS

A primary purpose of the expeditions exploring and mapping the West was the gathering of scientific information about the terrain, flora and fauna of this *terra incognita*. Indeed, of the leaders of the four most important surveys, three were venturesome scientists. Naturalist and professor of geology Ferdinand V. Hayden, employer of photographer William Henry Jackson, discovered some 44 organisms, from a moth to a fossil dinosaur. Hailed by his friend Henry Adams as the "best and brightest mind of his generation," geologist Clarence King, who worked with Timothy O'Sullivan, Carleton Watkins and A. J. Russell, was a dauntless adventurer and an art enthusiast as well as a skilled scientist. After his expeditionary years, King organized and became first head of the U. S. Geological Survey in 1879. Following his elevation to folk hero (he was known as the Conqueror of the Colorado), geologist and ethnologist John Wesley Powell, whose photographers were E.O. Beaman and John Hillers, directed the Bureau of American Ethnology and succeeded King as head of the U.S. Geological Survey. Only Lt. George Wheeler's survey, documented by O'Sullivan and William Bell, centered on the military advantages of topographical mapping and pinpointing natural resources.

Scientists of various disciplines accompanied all the expeditions, though in his autobiography William Henry Jackson sounds a cautionary note – on the Hayden survey, journalists and others lacking specific qualifications were listed as "naturalists." The nineteenth century was a time of extraordinary flowering in the sciences, which had been known simply as natural history and philosophy. From these beginnings grew the specialties of botany, zoology, geology, astronomy, meteorology, paleontology, archaeology and ethnology, or anthropology. The opportunity to participate in the expeditions was prized – to be able to find new specimens and species, and to collect, classify and study western plants, animals, rocks, fossils and artifacts made many a reputation. For those unable to undertake fieldwork, photographs of the scientific wonders of the West were an eagerly awaited substitute. The tree portraits complete with Latin names by Watkins were highly valued by Harvard professor Asa Gray, the nation's leading botanist and early supporter of Darwin's evolutionary theory.

Many of the nineteenth-century controversies over scientific and religious theories about the earth's origin centered on geology. The uniformitarians held that geological features slowly grew from natural forces working uniformly over a long time; the catastrophists believed that changes arose from sudden violent cataclysms. By the time of the expeditions, catastrophism was the predominant theory, leading to current speculation over how much influence Clarence King, a catastrophist, may have exerted over the photographic choices of O'Sullivan. Certainly the attention of expedition photographers to colossal boulders, buttes, bluffs, mountains, deserts, canyons, waterfalls, fissures, geysers and hot springs constitutes a legitimate cataloguing of the West's distinctive geological features and processes, regardless of the specific theories of the survey scientists. O'Sullivan's predilection for images of dramatically surreal land forms could reflect both his own expressive vision and nineteenth-century theories of geological cataclysm.

From its very birth, photography has been regarded as an ideal scientific tool. Long before it recorded western geology and archaeology, it was used to document botanical specimens, phases of the moon, the physiology of criminals and the insane, and the wounds of Civil War soldiers. Eadweard Muybridge's cloud studies and motion studies are scientific documents as well. As instructed by expedition scientists, the survey cameramen followed precise requirements that shaped the technique and content of their photographs.

In order to document typical and unusual geological formations in context, and to record natural forces changing land forms over time, the photographers started with sequential overall views, followed by nearer shots from multiple angles. The ideal photograph was straightforward, with a normal perspective, clear and detailed, with scale indicated usually by a human figure or wagon. A rephotographic survey project of the late 1970s, duplicating views by O'Sullivan and Jackson, revealed that absolute scientific accuracy can be elusive. Variations in quality of natural light, angle of view and framing affect the outcome. Considering a picture out of sequence or without descriptive notation can be misleading as well. O'Sullivan's *Sand Dunes, Carson Desert* reads as a detail of a sandy desert; actually it is of an isolated dune on a barren plain. Removed from the original context, the individual images transcend their role as scientific evidence to endure as artistic expression.

William Henry Jackson
Rocks Below Platte Canyon (Colorado), 1870

ACADEMY OF NATURAL SCIENCES, PHILADELPHIA, PA

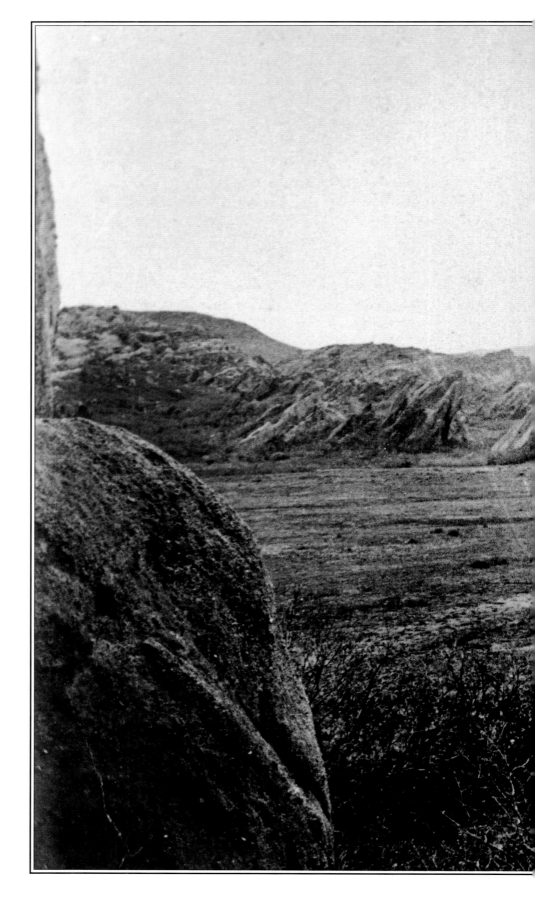

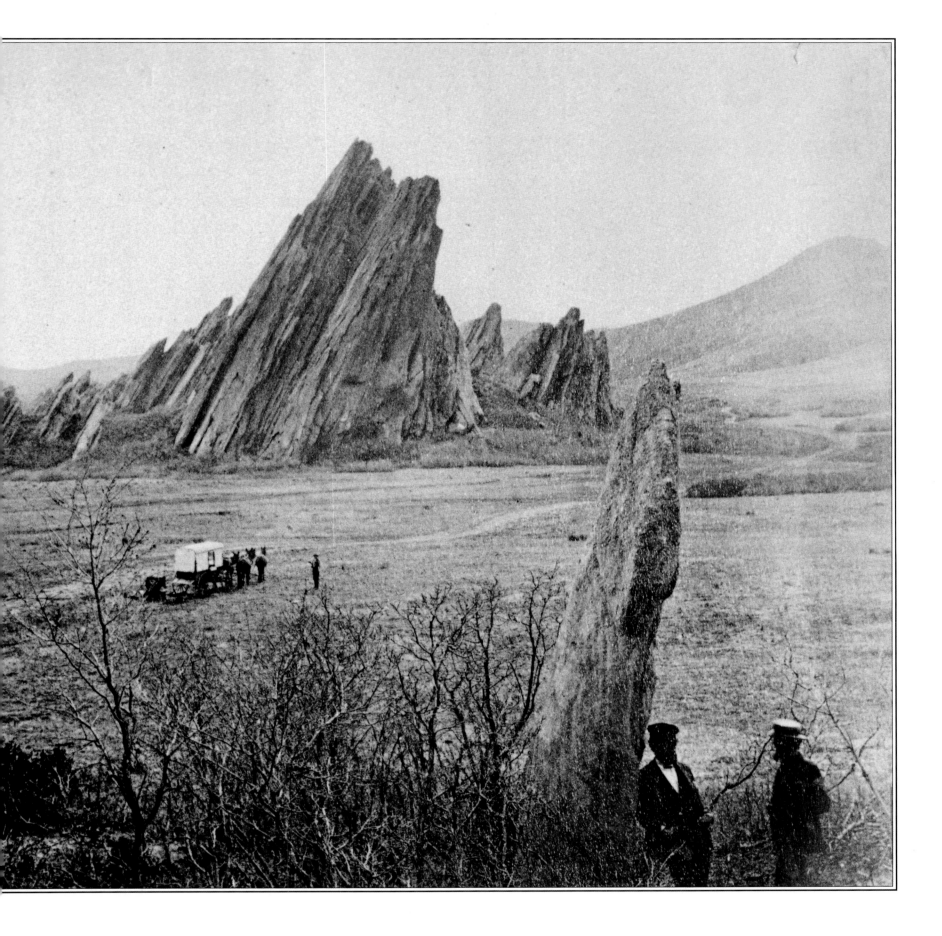

Andrew J. Russell
High Bluff, Black Buttes (Wyoming), 1867-68

BEINECKE RARE BOOK AND MANUSCRIPT LIBRARY,
YALE UNIVERSITY, NEW HAVEN, CT

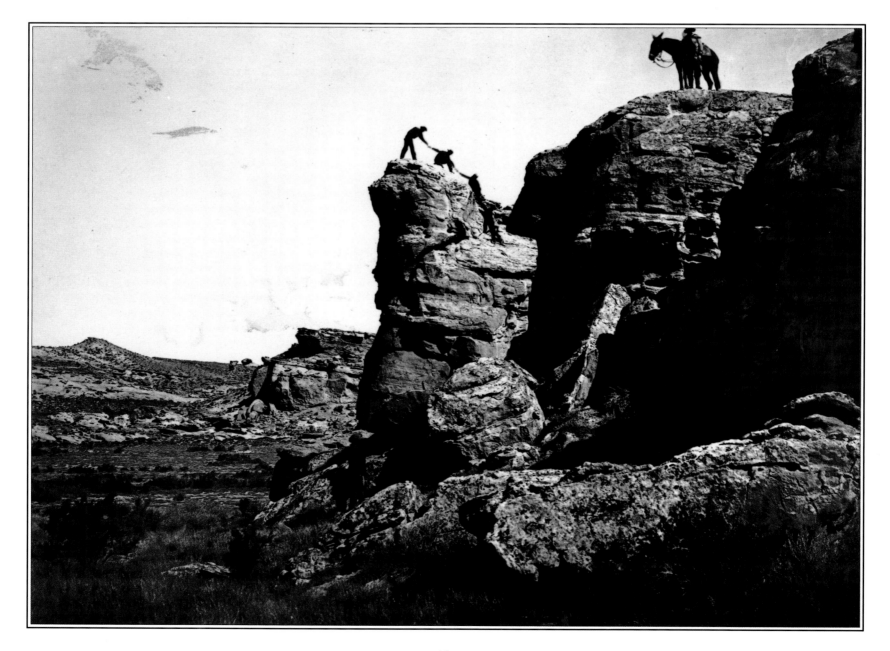

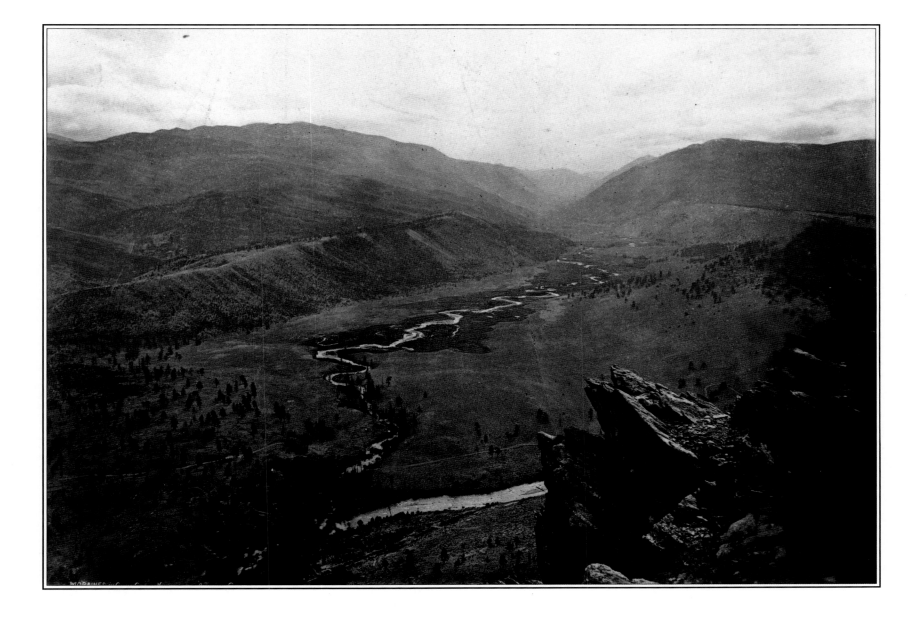

William Henry Jackson
*Moraines on Clear Creek, Valley of
the Arkansas, Colorado, 1873*

BEINECKE RARE BOOK AND MANUSCRIPT LIBRARY,
YALE UNIVERSITY, NEW HAVEN, CT

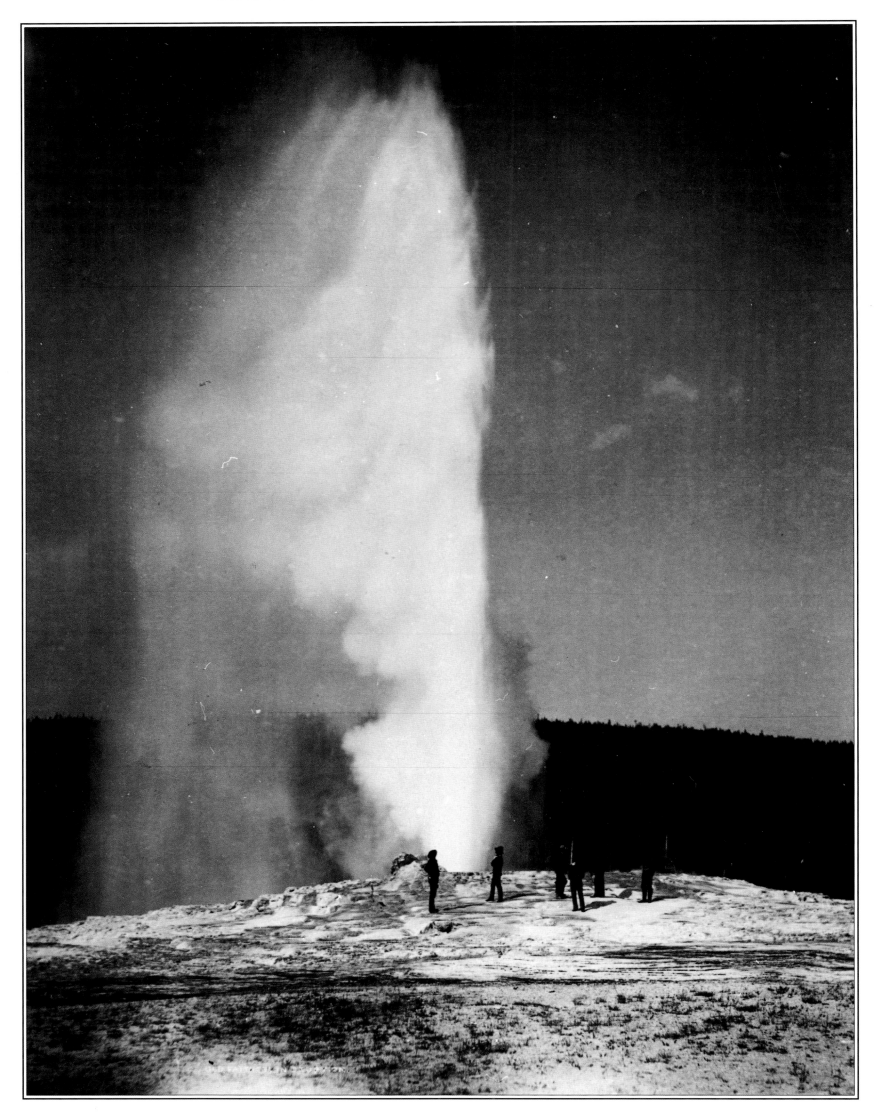

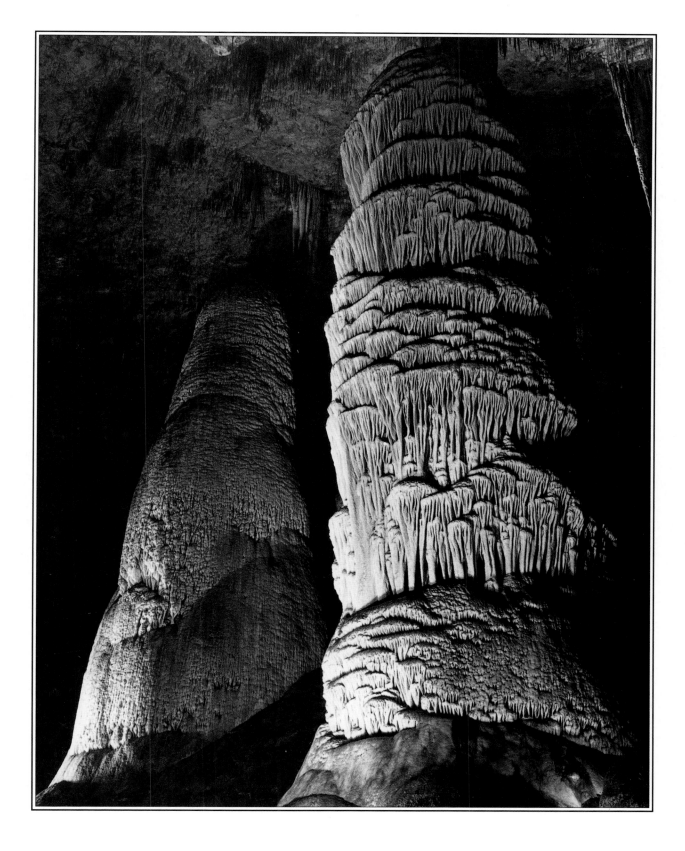

LEFT:
William Henry Jackson
Old Faithful in Eruption, Yellowstone, Wyoming, 1872

PHOTO ARCHIVES, MUSEUM OF NEW MEXICO

SANTA FE, NM

Ansel Adams
*The Giant Dome, Largest Stalagmite
thus far Discovered, Carlsbad Caverns
National Park, New Mexico*

NATIONAL ARCHIVES

WASHINGTON, D.C.

47

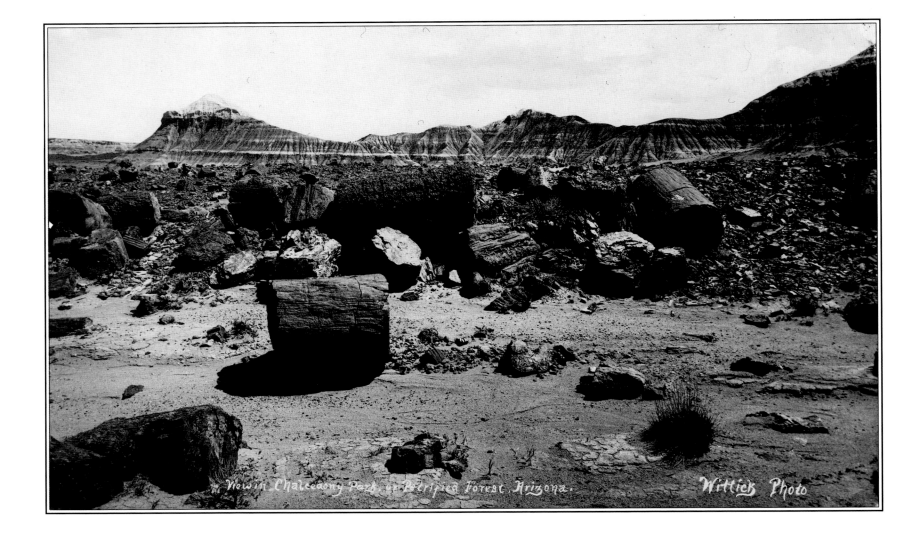

Ben Wittick
View in Chalcedony Park, Petrified Forest,
Arizona, c. 1883

PHOTO ARCHIVES, MUSEUM OF NEW MEXICO

SANTA FE, NM

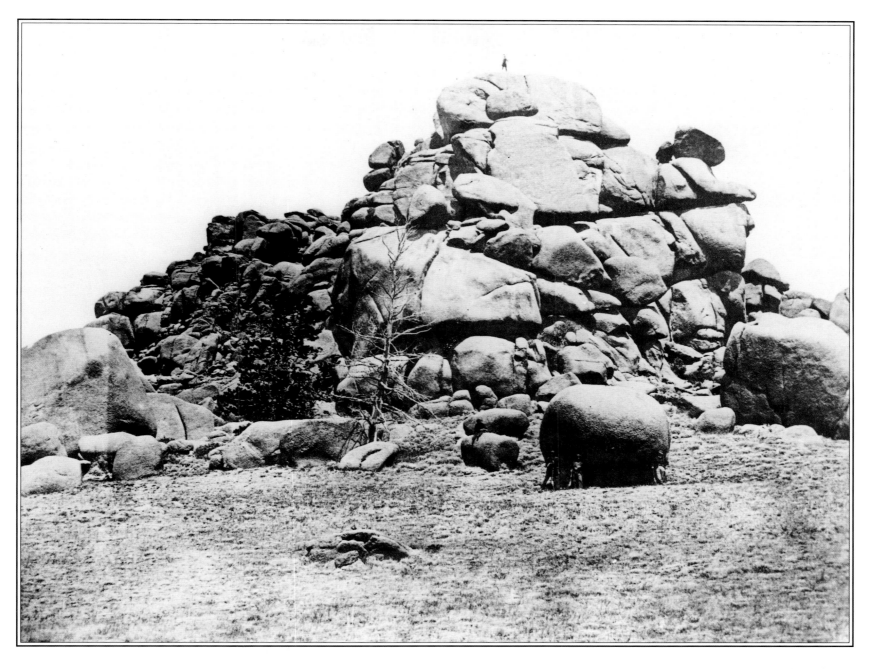

Andrew J. Russell
Skull Rock, Sherman Station
Laramie Mountains, Wyoming

PHOTO ARCHIVES, MUSEUM OF NEW MEXICO

SANTA FE, NM

Timothy O'Sullivan
Tufa Domes, Pyramid Lake,
1867

BEINECKE RARE BOOK AND MANUSCRIPT
LIBRARY, YALE UNIVERSITY
NEW HAVEN, CT

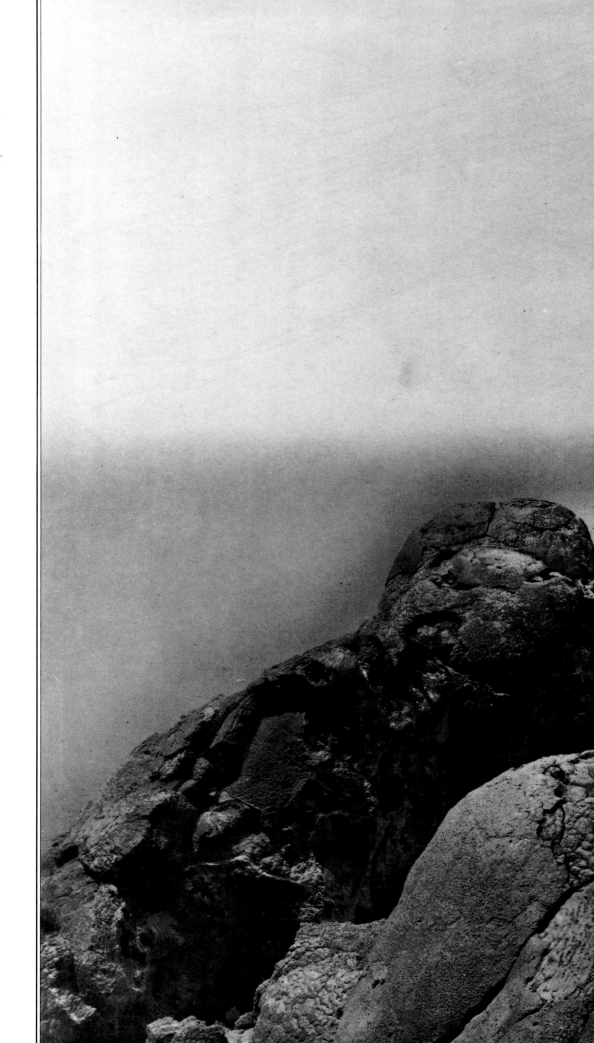

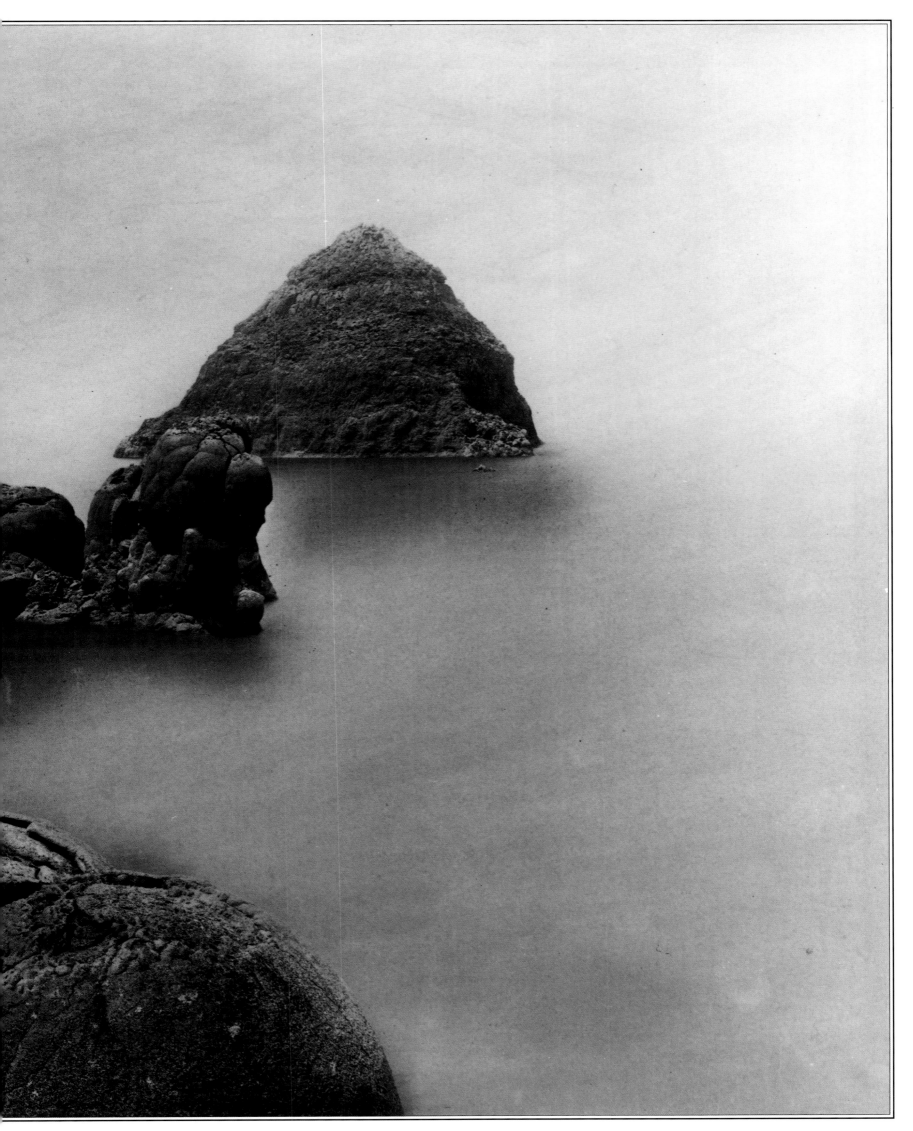

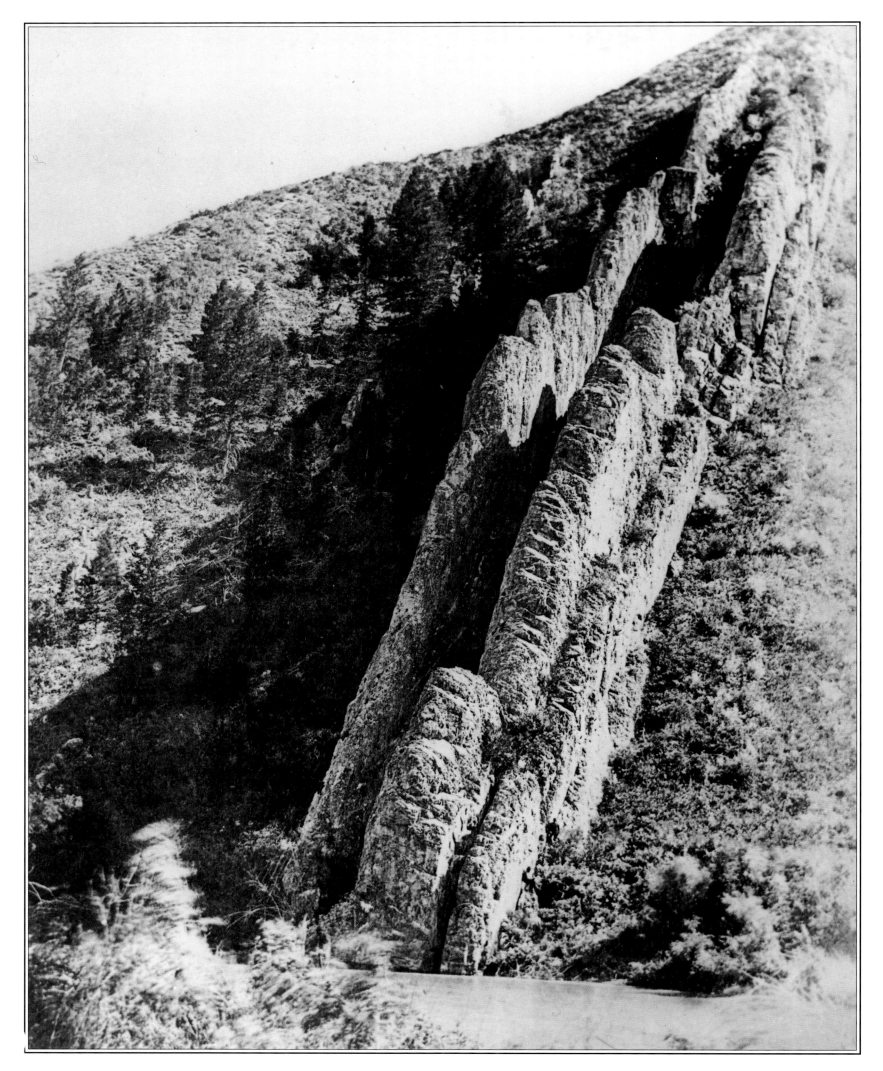

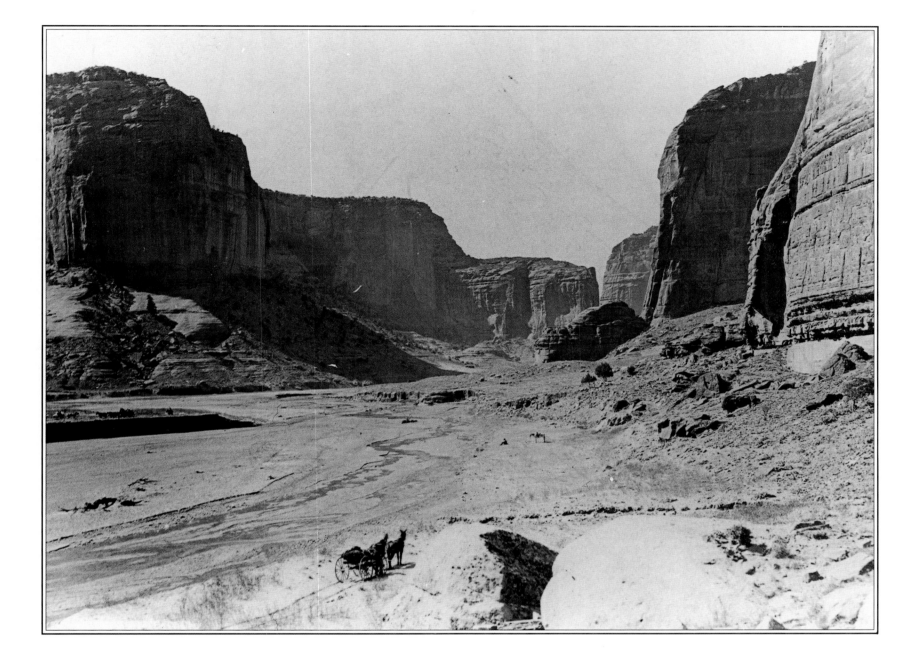

LEFT:
Andrew J. Russell
Serrated Rocks or Devil's Slide,
Weber Canyon, Utah

PHOTO ARCHIVES, MUSEUM OF NEW MEXICO

SANTA FE, NM

John K. Hillers
View from Face Rock, Canyon de Chelly,
Arizona, 1882

PHOTO ARCHIVES, MUSEUM OF NEW MEXICO

SANTA FE, NM

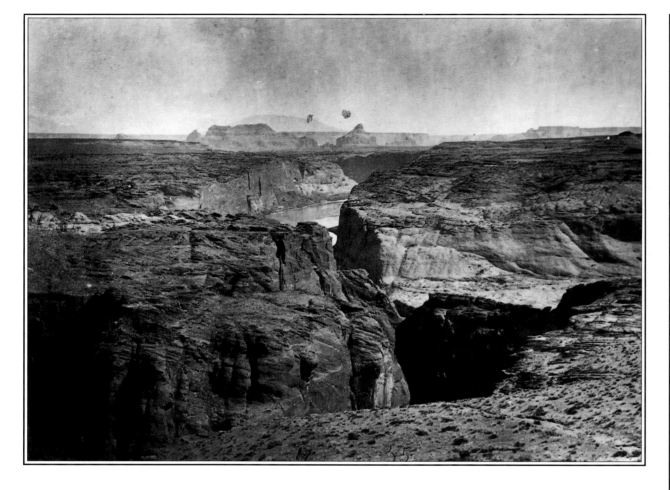

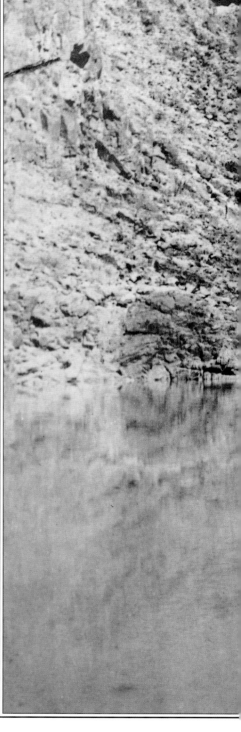

Timothy O'Sullivan
*Canyon of the Colorado River, near
the mouth of the San Juan River, Arizona, c. 1873*

PHOTO ARCHIVES, MUSEUM OF NEW MEXICO

SANTA FE, NM

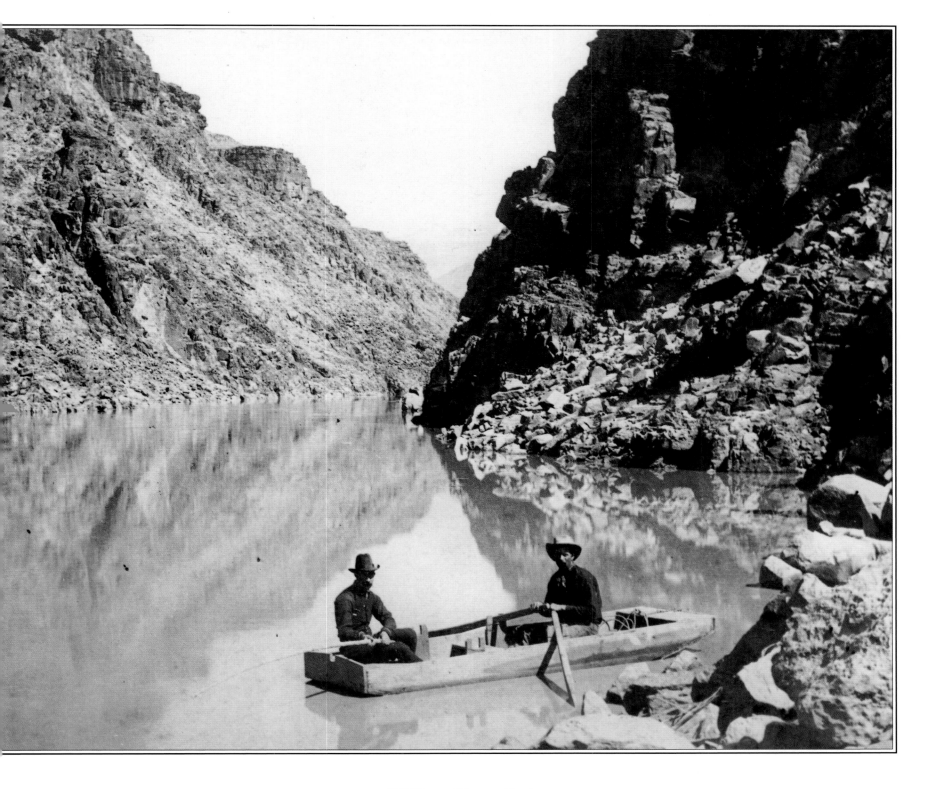

William Henry Jackson
Grand Canyon of the Colorado, Arizona, c. 1883-85

PHOTO ARCHIVES, MUSEUM OF NEW MEXICO

SANTA FE, NM

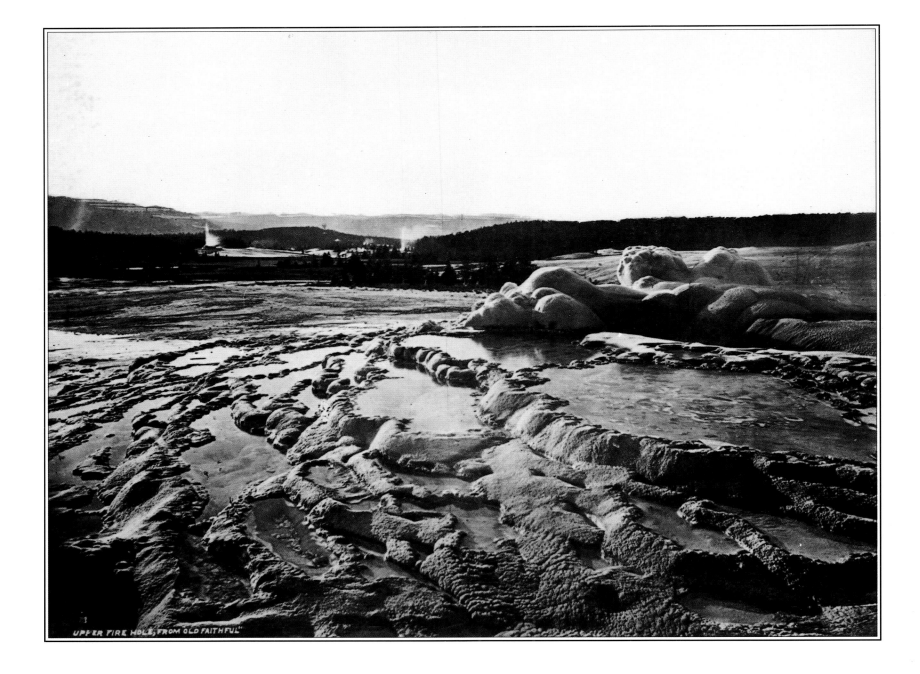

William Henry Jackson
Upper Fire Hole from Old Faithful, Yellowstone, 1872

PHOTO ARCHIVES, MUSEUM OF NEW MEXICO

SANTA FE, NM

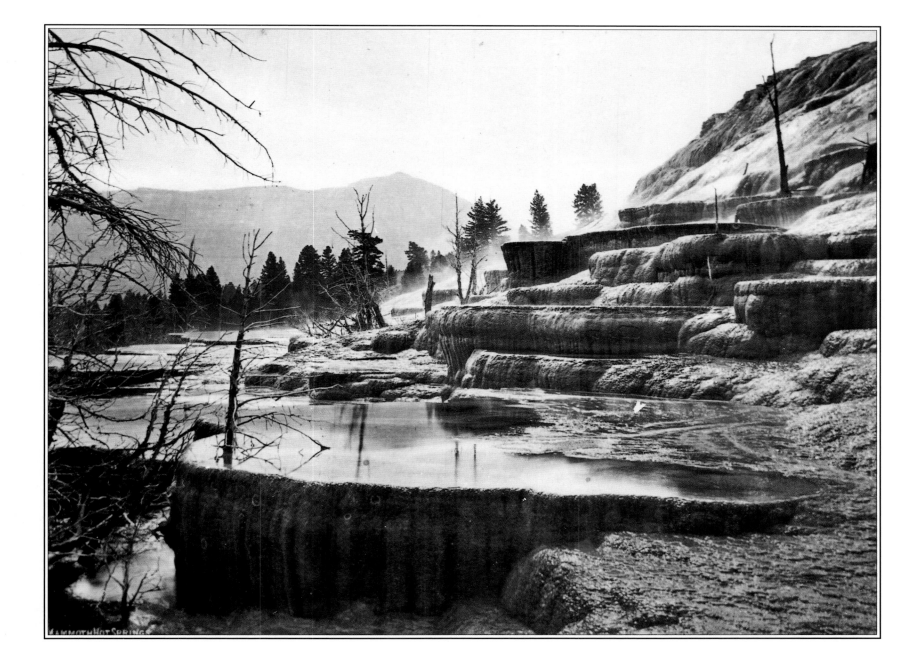

William Henry Jackson
Mammoth Hot Springs, Yellowstone, 1872

PHOTO ARCHIVES, MUSEUM OF NEW MEXICO

SANTA FE, NM

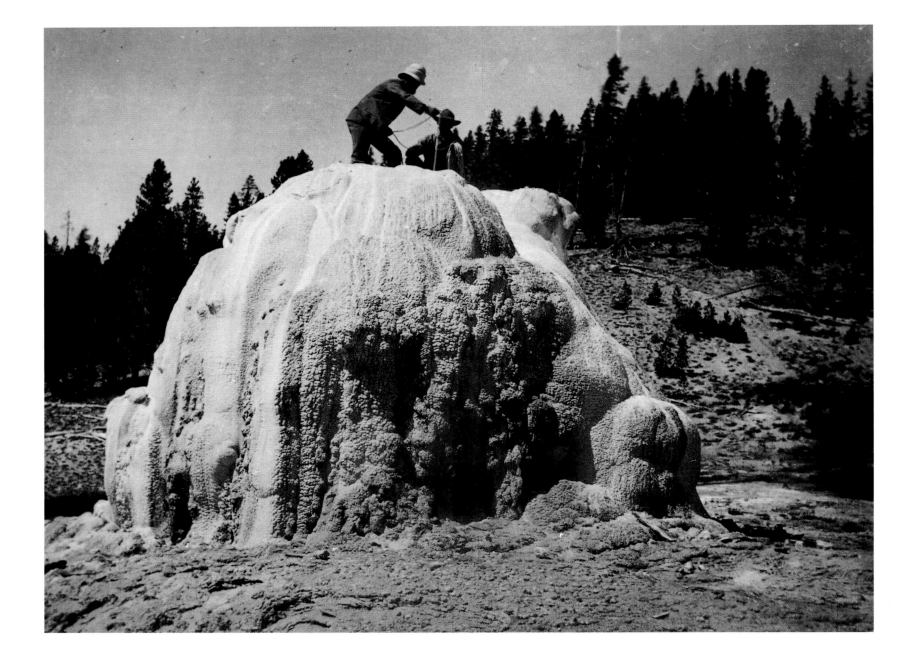

William Henry Jackson
Crater of the Lone Star Geyser, Yellowstone, 1872

PHOTO ARCHIVES, MUSEUM OF NEW MEXICO

SANTA FE, NM

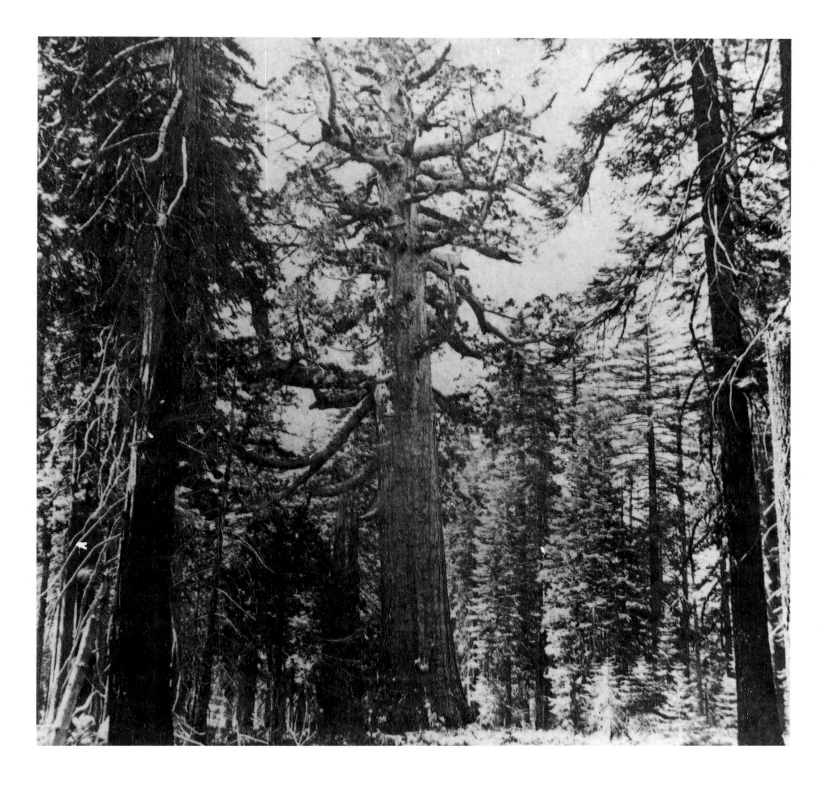

Carleton E. Watkins
Grizzly Giant, Mariposa Grove, Yosemite, CA

PHOTO ARCHIVES, MUSEUM OF NEW MEXICO

SANTA FE, NM

F. Jay Haynes
Grotto Geyser Cone, Yellowstone

PHOTO ARCHIVES, MUSEUM OF NEW MEXICO
SANTA FE, NM

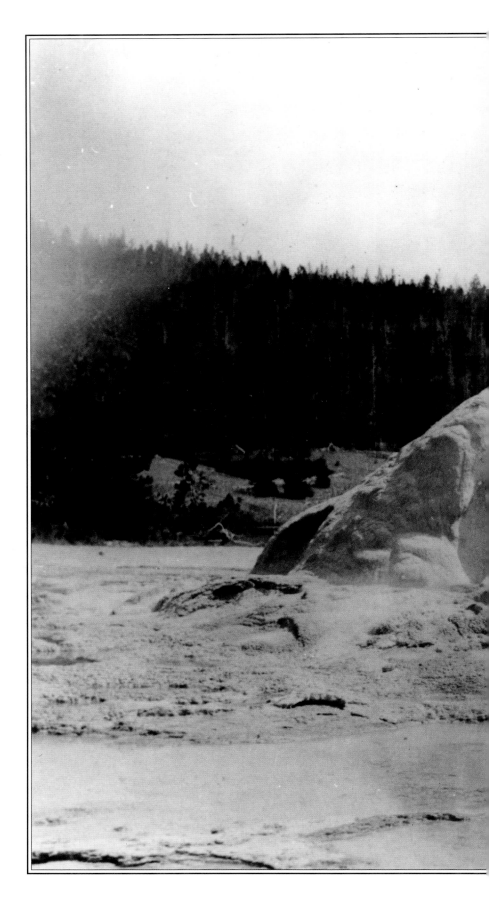

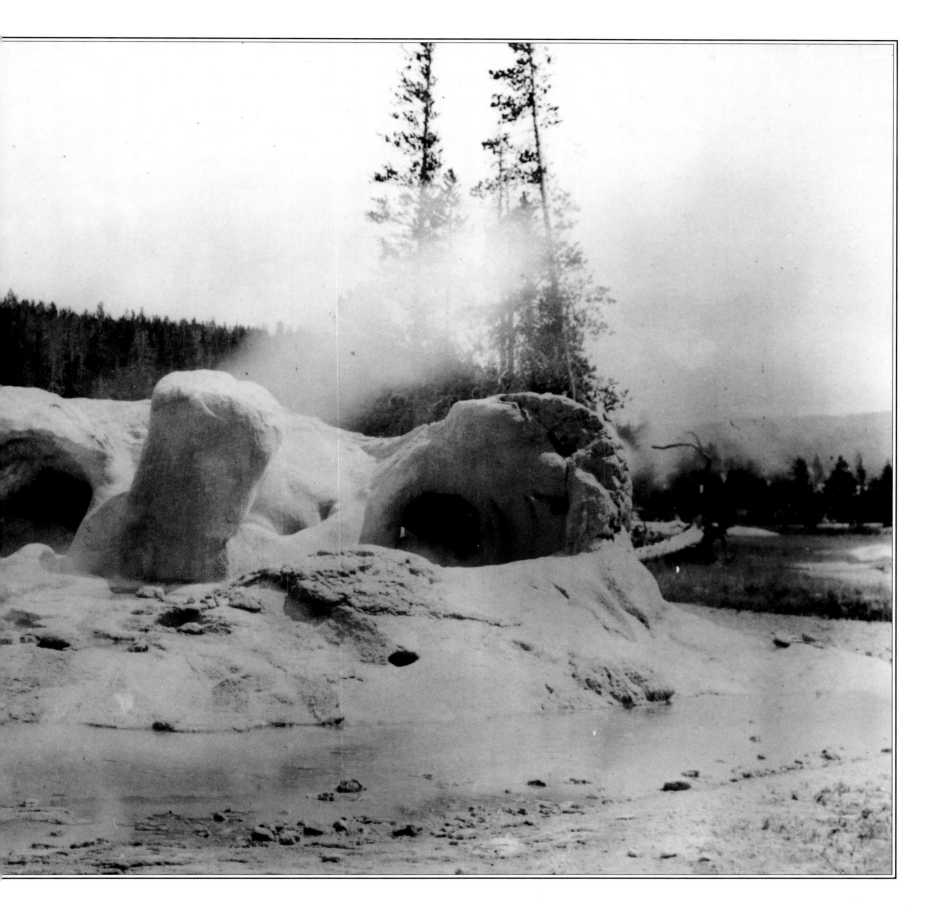

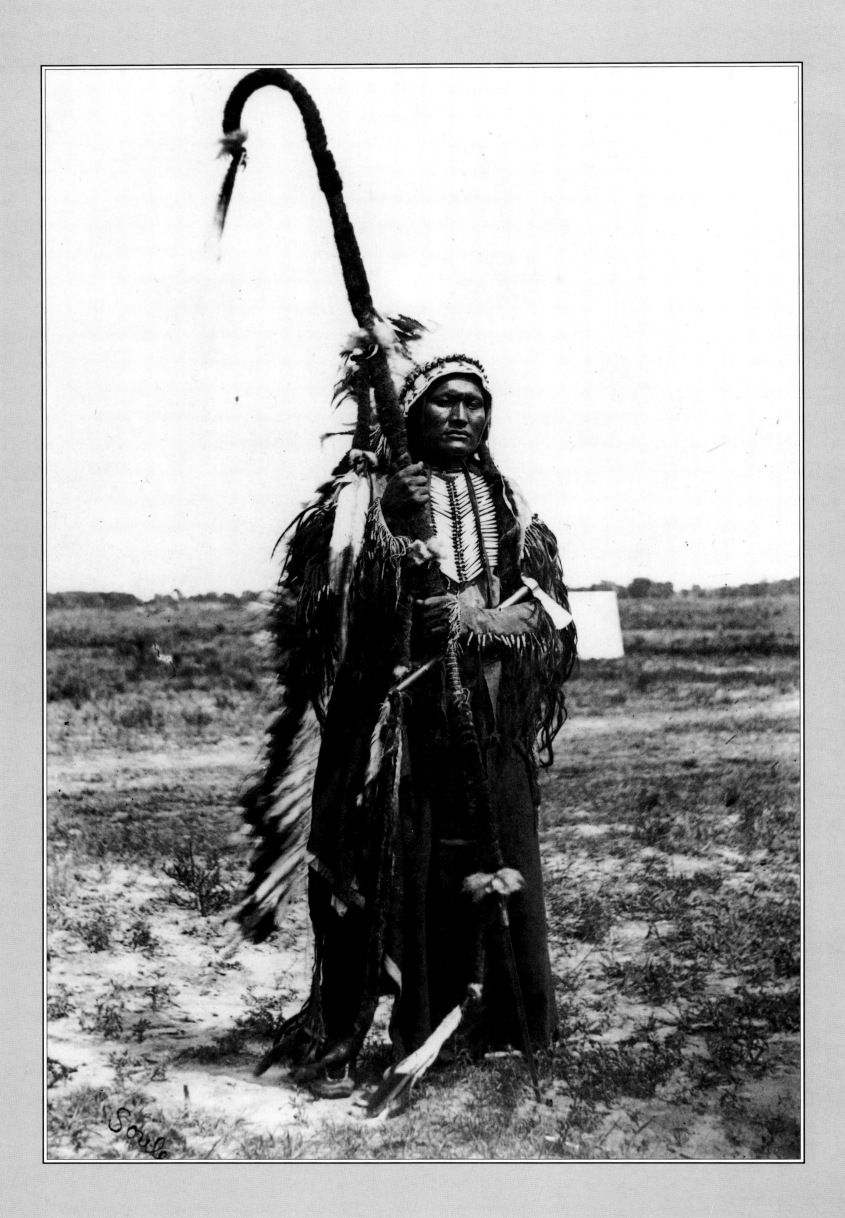

THE NATIVE AMERICANS

Ever since European colonists first set foot on the continent, they regarded the Native American peoples with ambivalence. Throughout the nineteenth century, as the frontier was opened to exploration, exploitation and settlement, the Native American was seen alternately in a positive and a negative light, depending on the prevailing historic circumstances. The romantic image of the Noble Savage – the idealized natural man who embodied wilderness virtues and lived in harmony with nature, far from civilization's corrupting influences – was portrayed from the 1820s to 1850s in paintings by Charles Bird King, George Catlin and others. With the big push westward came the contrasting stereotype of the barbaric and bloodthirsty menace who, in literary and visual media, was seen as violent, primitive, superstitious and deceptive, while white settlers were portrayed as their innocent victims. This ethnocentric view ignored the injustices and brutalities inflicted on the Native Americans as they were forcibly removed from ancestral lands; rather it rationalized their harsh treatment. A third view persisted throughout much of the century, although it subsided during the Great Plains wars of the 1860s and 1870s. This was the nostalgic idea of the doomed or Vanishing Indian, recurrent in art and literature, as in James Fenimore Cooper's *The Last of the Mohicans*. After the western tribes finally were subdued, and they were no longer a threat to settlers, the Noble Savage and the Vanishing Indian resurfaced as popular motifs, especially in photography.

The idea of the Vanishing Indian lent urgency to his preservation, at least by the camera. From the 1850s on, Washington, D.C., was a center for the photography of Native Americans. Nearly all tribal leaders who came to deal with the government were photographed, at first by independent studio cameramen such as Alexander Gardner and later systematically by those working for the Bureau of American Ethnology, including John Hillers and DeLancey Gill. These stiffly posed studio portraits served several purposes. One was to collect anthropometric data, another was to document tribal costume, and the third was to capture famous personalities for history.

Of the major expeditionary photographers, Timothy O'Sullivan, John Hillers and William Henry Jackson actively photographed Native Americans on the frontier. Intended as part of the scientific documentation of the West, these were ostensibly straightforward depictions of Native Americans and their natural environment. Nevertheless, the value of these photographs as an accurate record is dubious. One problem concerns the text accompanying the images. The same photographs used in different contexts sometimes were described differently. The captions could be powerful and misleading agents in shaping the viewer's perceptions. Furthermore it is not always clear whether the subjects have been posed to seem more artistic or more typical. One of the more questionable practices involved providing clothes and props more "authentic" than their own, as many Native Americans had adopted the white man's apparel for everyday use. This occasional costuming began with such Washington studio photographers as Gardner and was continued by such frontier studio cameramen as William Soule. Of the photographers engaged in fieldwork, John Hillers and Edward Curtis also are known to have supplied costumes at times. The reason was largely economic – the image of the exotic Red Man of the Old West was one that sold pictures. Profit also influenced George Trager, who documented the 1890 aftermath of Wounded Knee. An important historic record of the battle ending the Indian wars, his pictures reached a wide audience, thanks to energetic marketing. While Trager photographed, his partner collected weapons and Ghost Dance shirts to sell as souvenirs. Nor were Native Americans oblivious to their exploitation. Geronimo charged ten cents for a portrait with a hand-held camera, 25 cents for one with a tripod and two dollars for a studio sitting. And the Hopi, who faced the burden of increasing tourism, banned all photography by 1911.

While the work of Edward Curtis perpetuated the motifs of the Noble Savage and the Vanishing Indian, it was a remarkable artistic achievement owing much to the stylistic manipulations of soft-focus pictorialism. Ben Wittick's straightforward photographs of Native Americans were inspired by his interest in documenting cultures that he perceived to be threatened. The least biased and most sensitive images came from those photographers who lived among their subjects for a time, as did Laura Gilpin, or those who developed a deep respect for their traditions and way of life, as did Adam Clark Vroman and Ansel Adams. Theirs were pictures of individuals enduring into the modern West, rather than a catalogue of anthropological specimens or nostalgic resurrections of stereotypes.

LEFT:
William Soule
War Chief of the Arapahoe, Powder Face

PHOTO ARCHIVES, MUSEUM OF NEW MEXICO, SANTA FE, NM

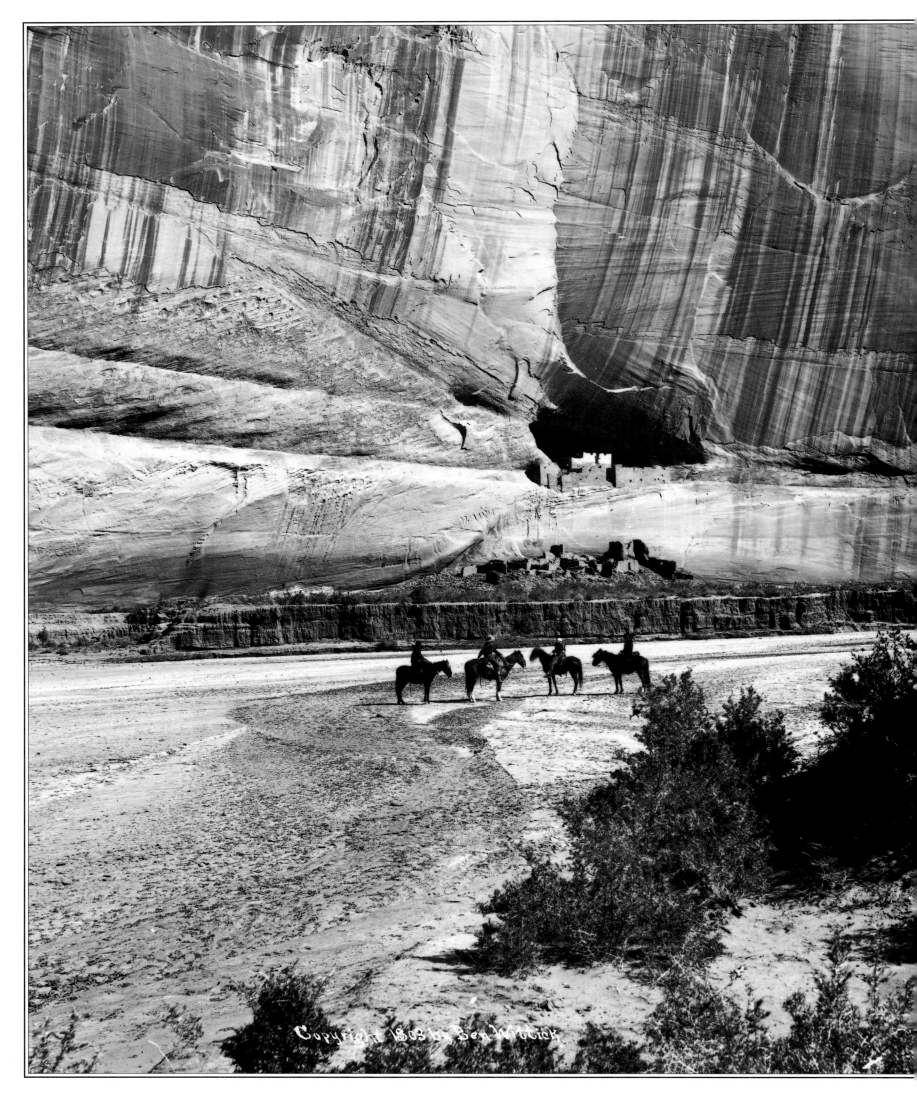

Copyright 1903 by Ben Wittick

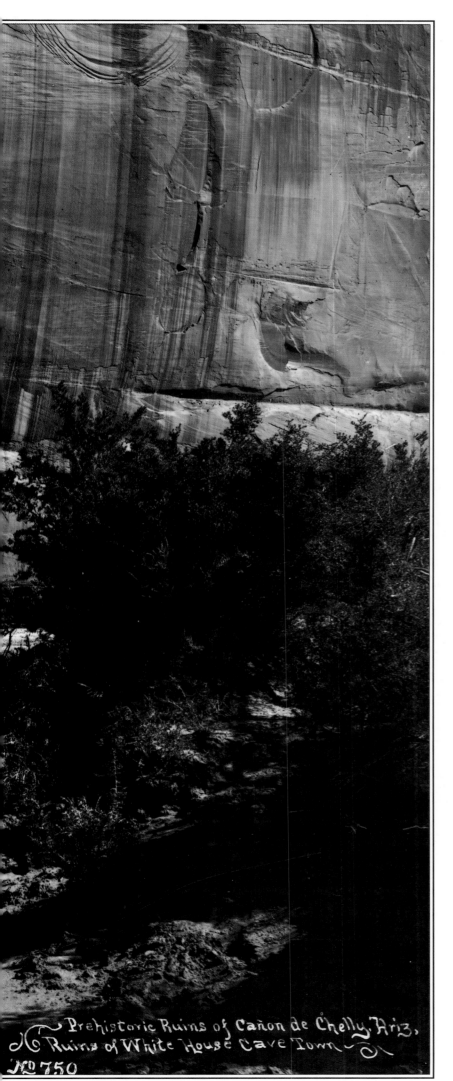

Ben Wittick
White House Ruins, Canyon de Chelly, Arizona, 1903

PHOTO ARCHIVES, MUSEUM OF NEW MEXICO

SANTA FE, NM

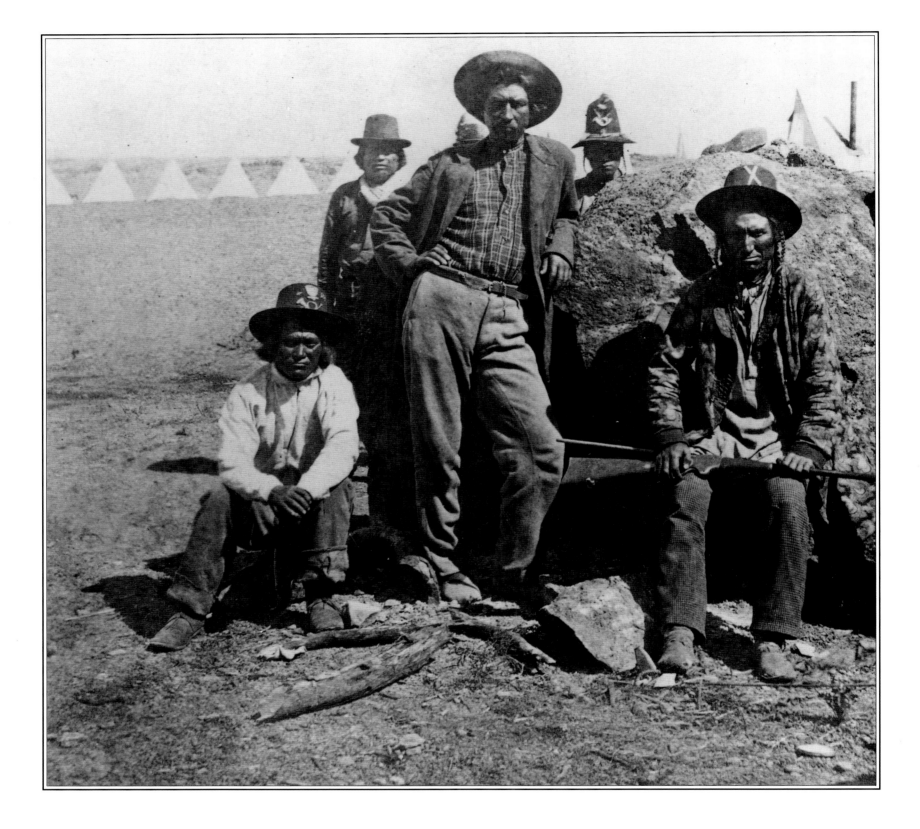

Eadweard Muybridge
Donald McKay, the Celebrated
Warm Springs Indian and His Chief Scout

PHOTO COLLECTION, CALIFORNIA STATE LIBRARY,

SACRAMENTO, CA

RIGHT:
Timothy O'Sullivan
Aboriginal Life Among the Navaho Indians, 1873

UPI/BETTMANN

NEW YORK, NY

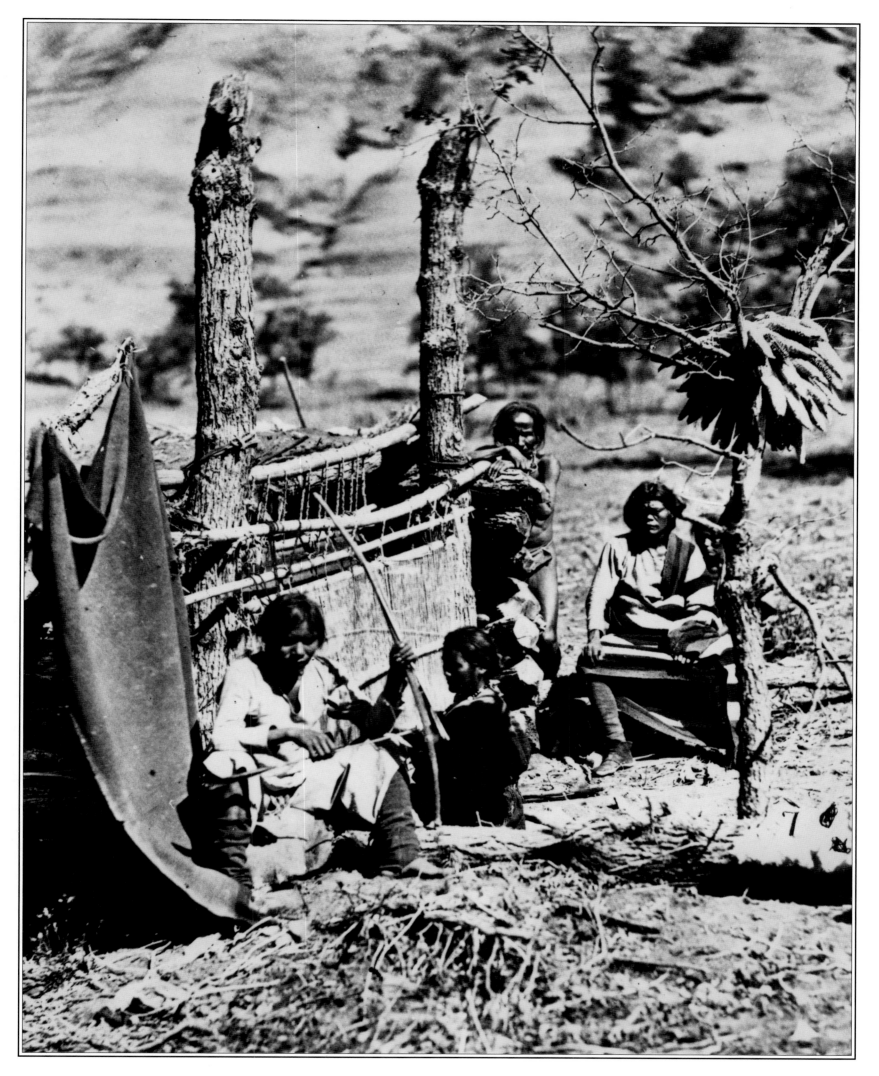

Ansel Adams
Cliff Dwellings, Mesa Verde National Park, 1941

NATIONAL ARCHIVES
WASHINGTON, D.C.

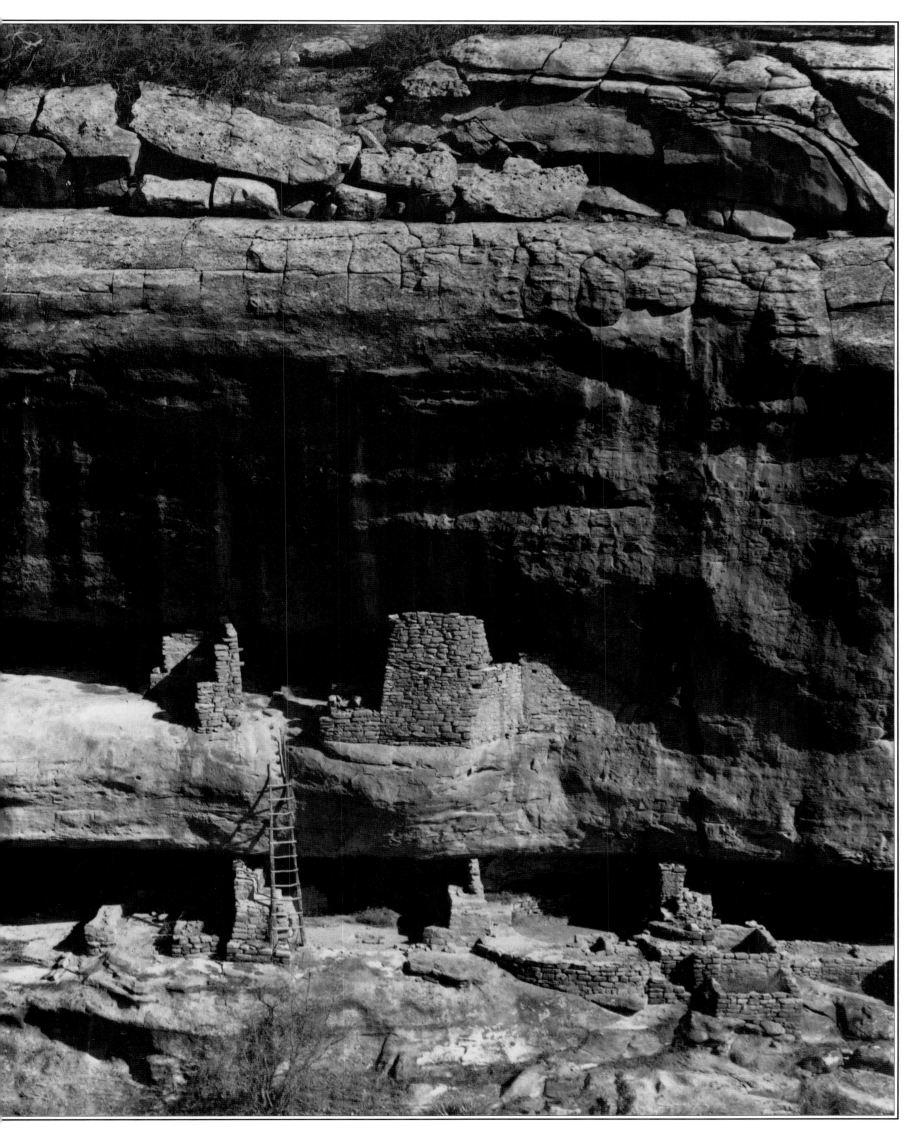

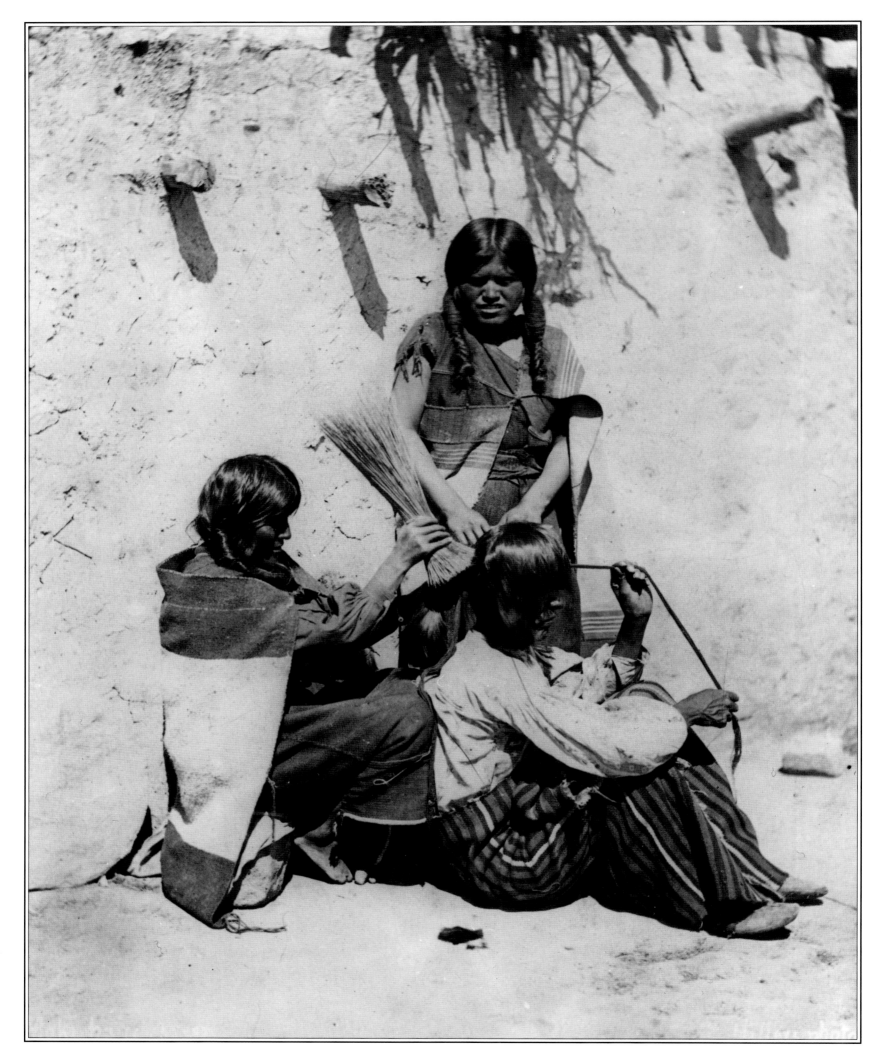

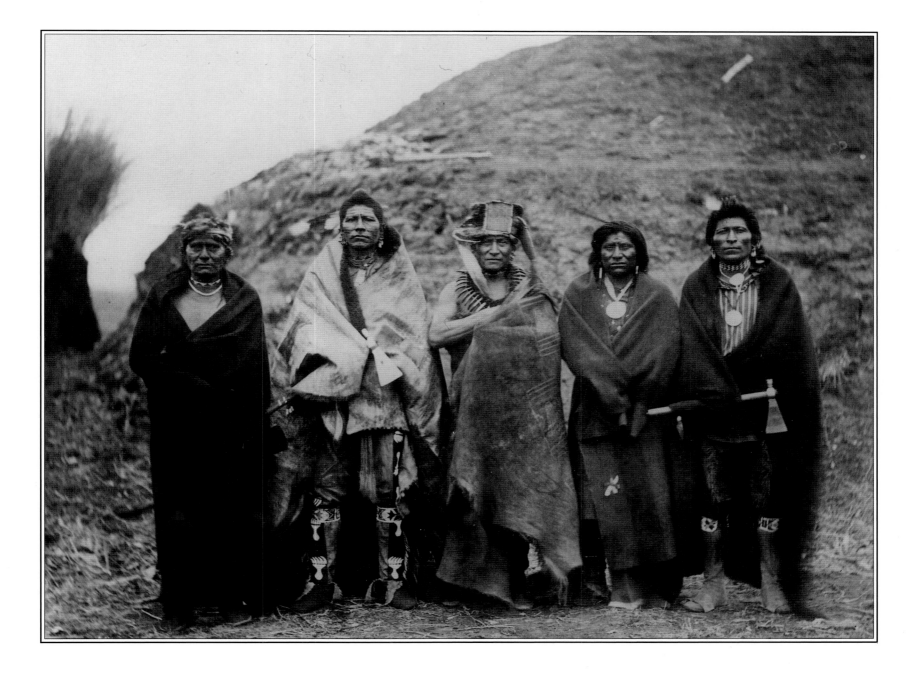

LEFT:
John K. Hillers
A Hopi Hairdresser, Hopi, Arizona, c. 1880-82

William Henry Jackson
Pawnee Men Before Earth Lodge, c. 1868-69

PHOTO ARCHIVES, MUSEUM OF NEW MEXICO

SANTA FE, NM

PHOTO ARCHIVES, MUSEUM OF NEW MEXICO

SANTA FE, NM

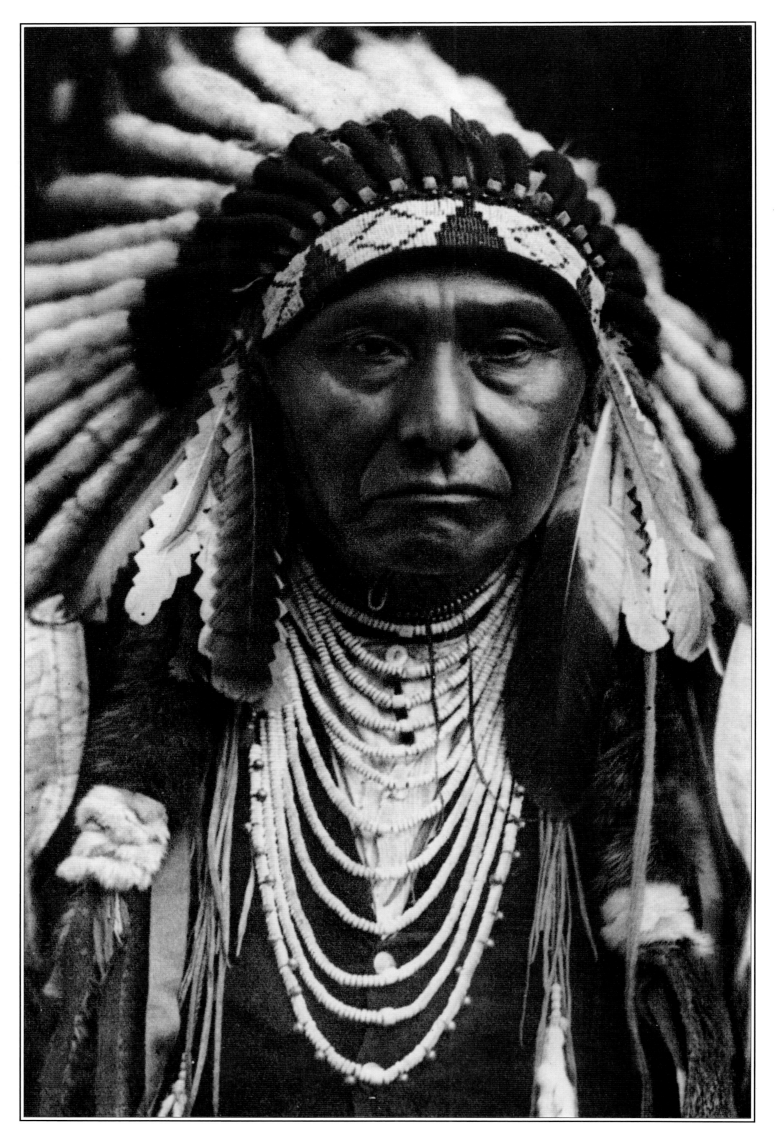

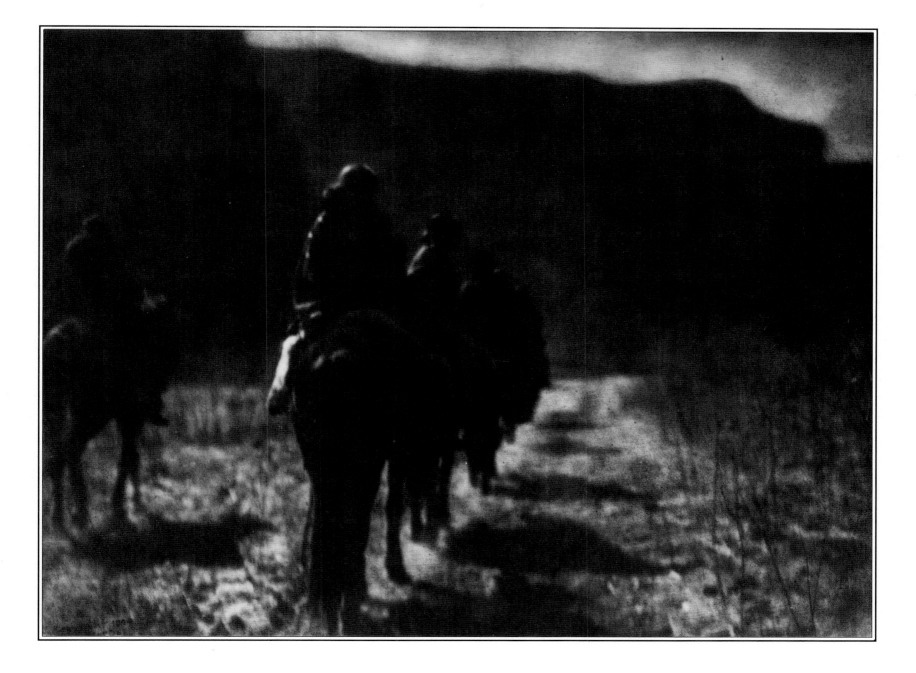

LEFT:
Edward S. Curtis
Chief Joseph, Nez Perce

SPECIAL COLLECTIONS DIVISION
UNIVERSITY OF WASHINGTON LIBRARIES
SEATTLE, WA

Edward S. Curtis
The Vanishing Race – Navaho

LIBRARY OF CONGRESS
WASHINGTON, D.C.

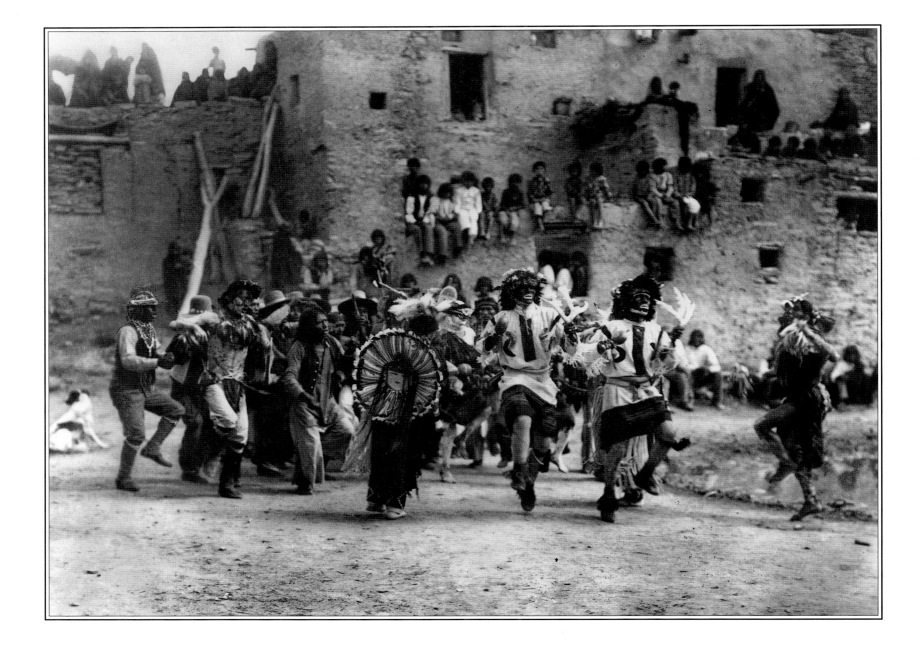

Edward S. Curtis
Buffalo Dance at Hano

LIBRARY OF CONGRESS

WASHINGTON, D.C.

RIGHT:
Edward S. Curtis
Placating the Spirit of a Slain Eagle – Assiniboin

LIBRARY OF CONGRESS

WASHINGTON, D.C.

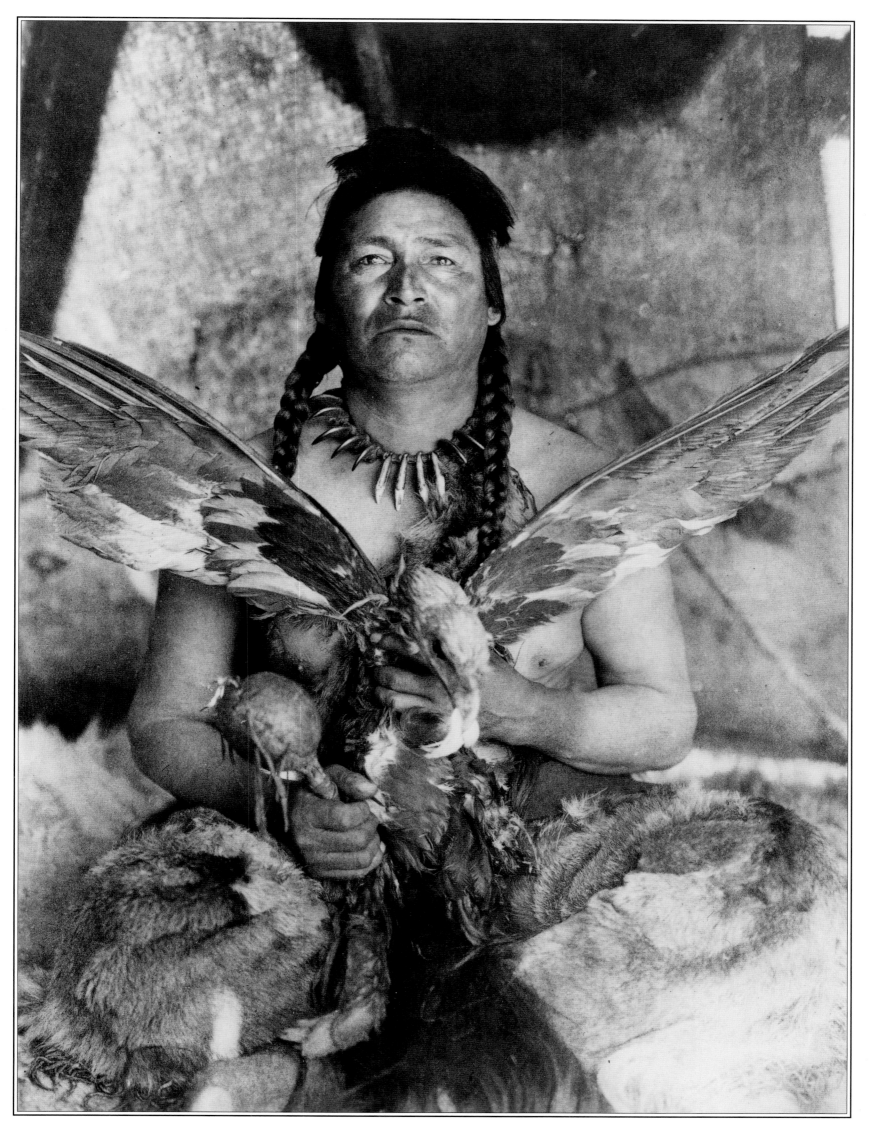

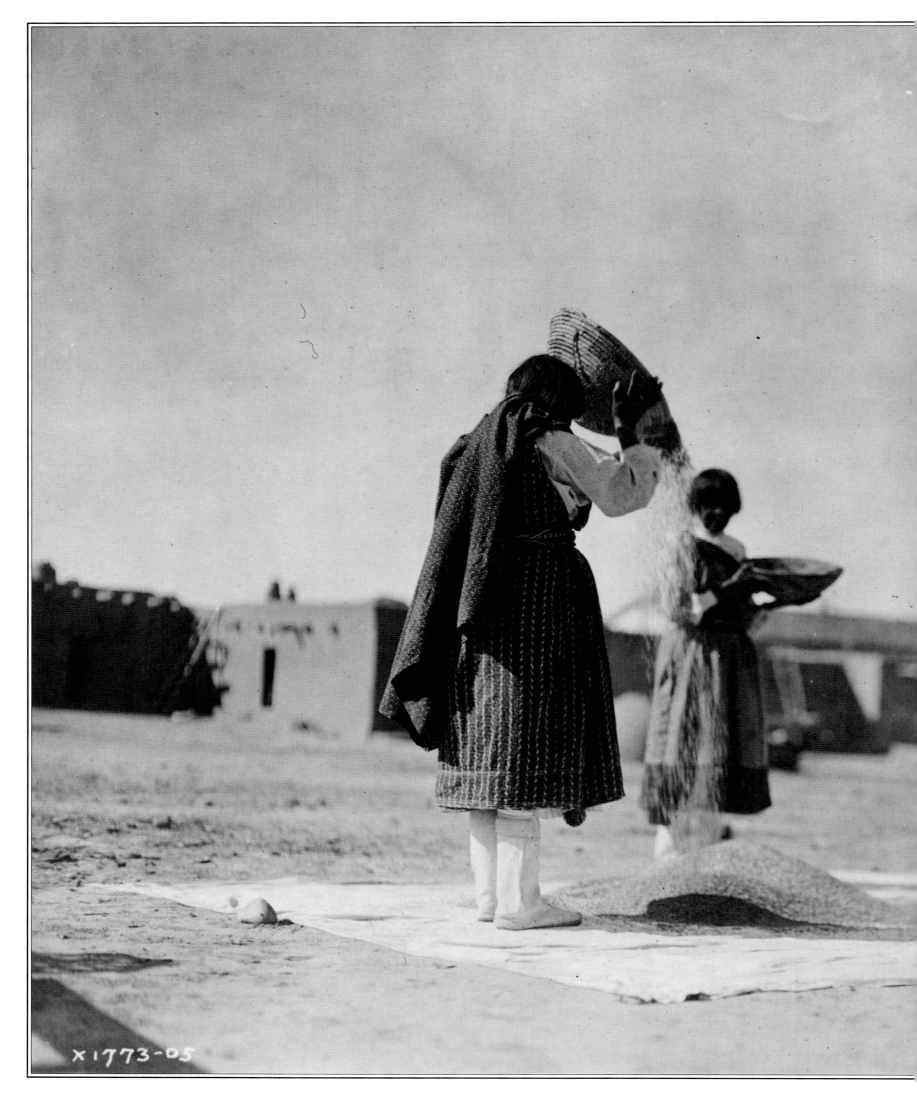

X1773-05

Edward S. Curtis
Winnowing Wheat – San Juan

LIBRARY OF CONGRESS
WASHINGTON, D.C.

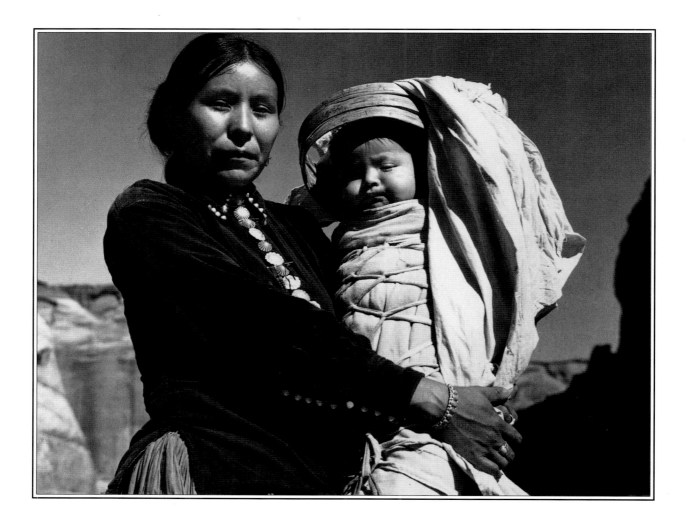

Ansel Adams
Navajo Woman and Infant, Canyon de Chelly, Arizona

NATIONAL ARCHIVES
WASHINGTON, D.C.

RIGHT:
Timothy O'Sullivan
Two Mohave Braves, 1871

NATIONAL ARCHIVES
WASHINGTON, D.C.

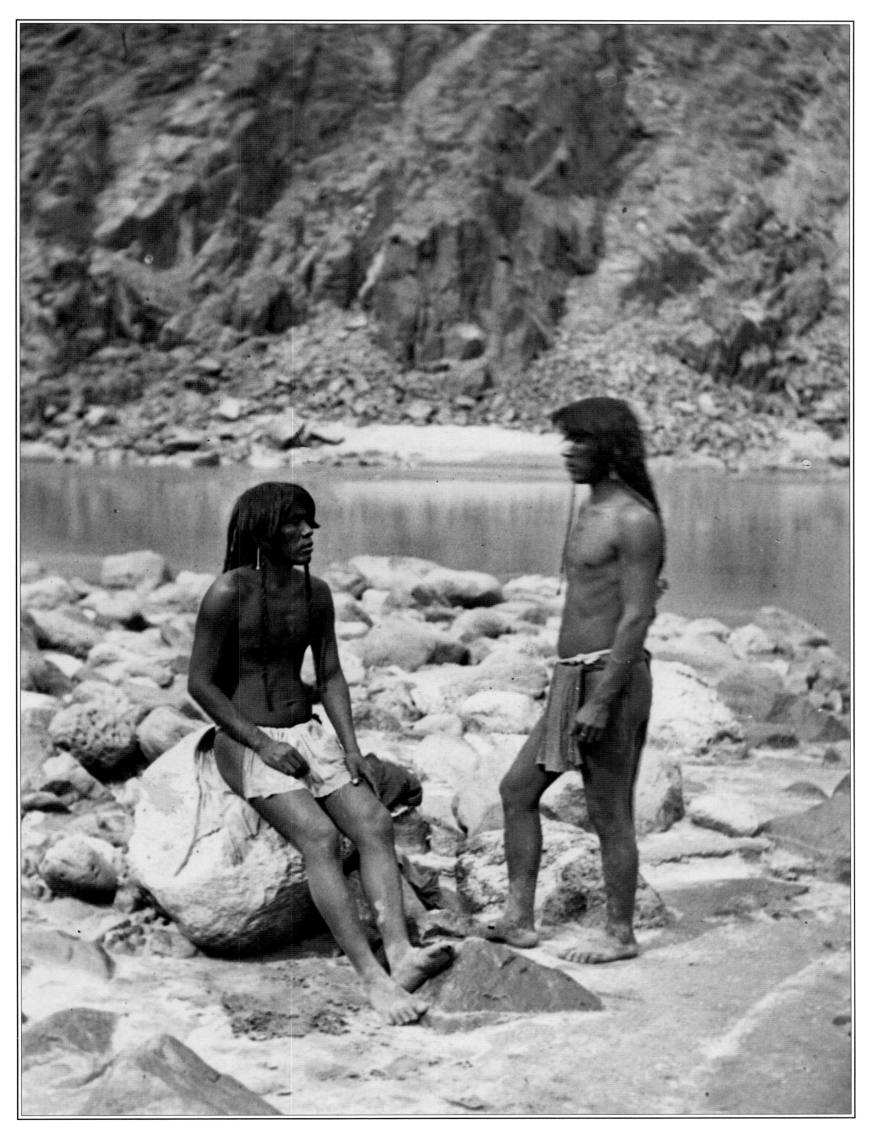

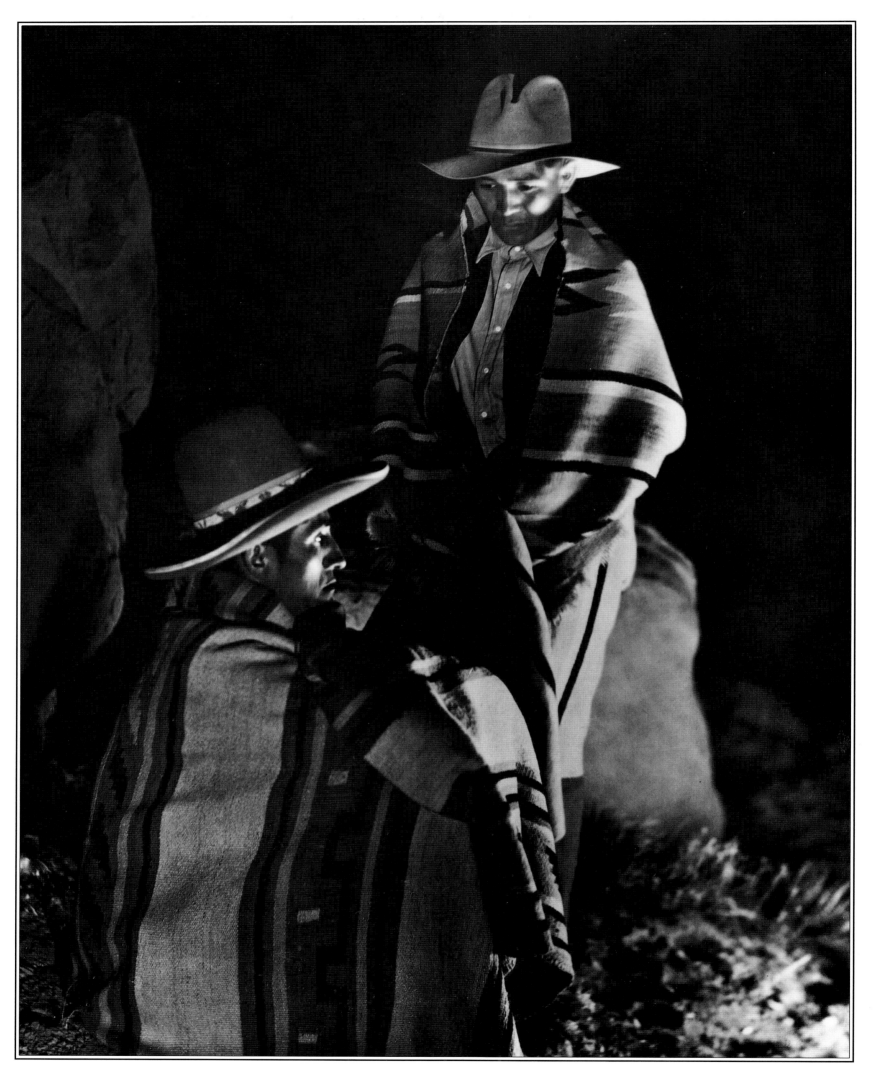

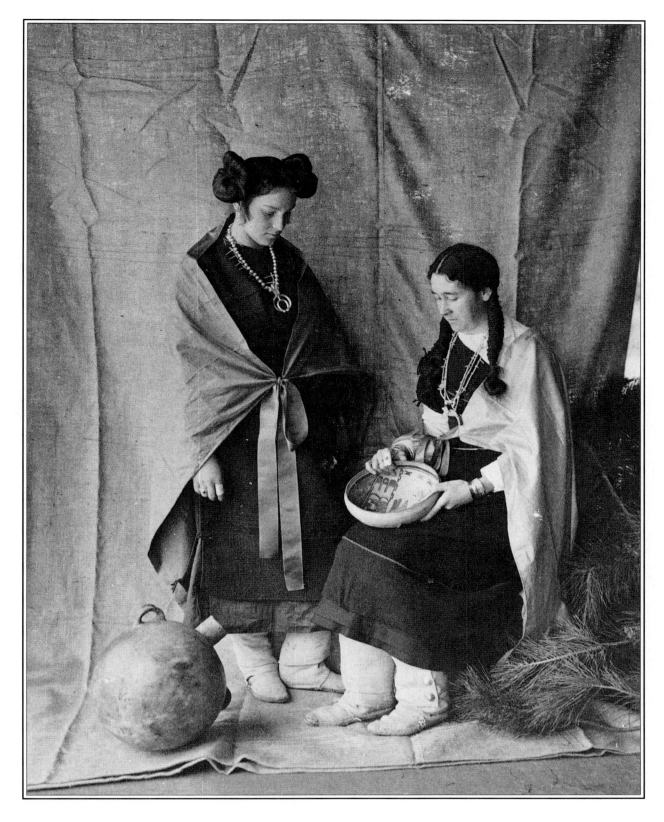

Laura Gilpin
Navajos by Firelight

PHOTOGRAPHY COLLECTION
AMON CARTER MUSEUM, FORT WORTH, TX

Adam Clark Vroman
Two Women by Pots, 1895-1904

PHOTOGRAPHY COLLECTION
AMON CARTER MUSEUM, FORT WORTH, TX

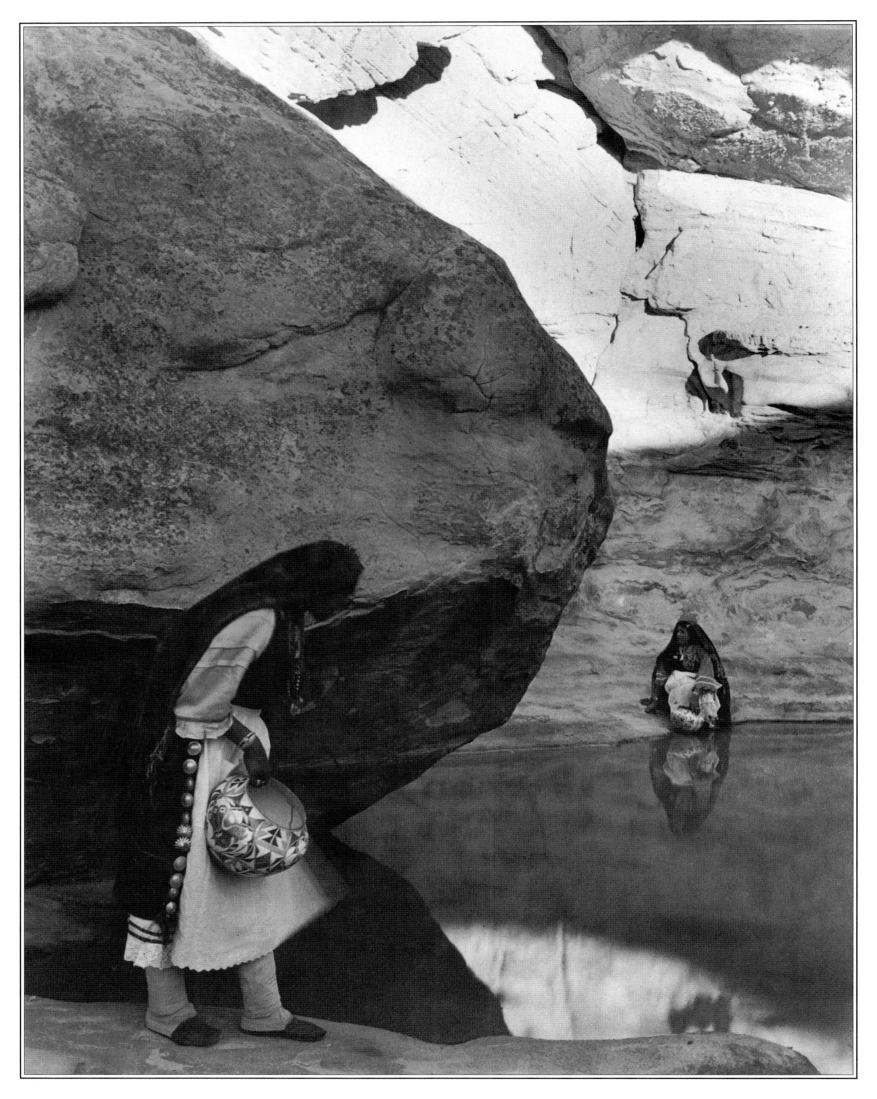

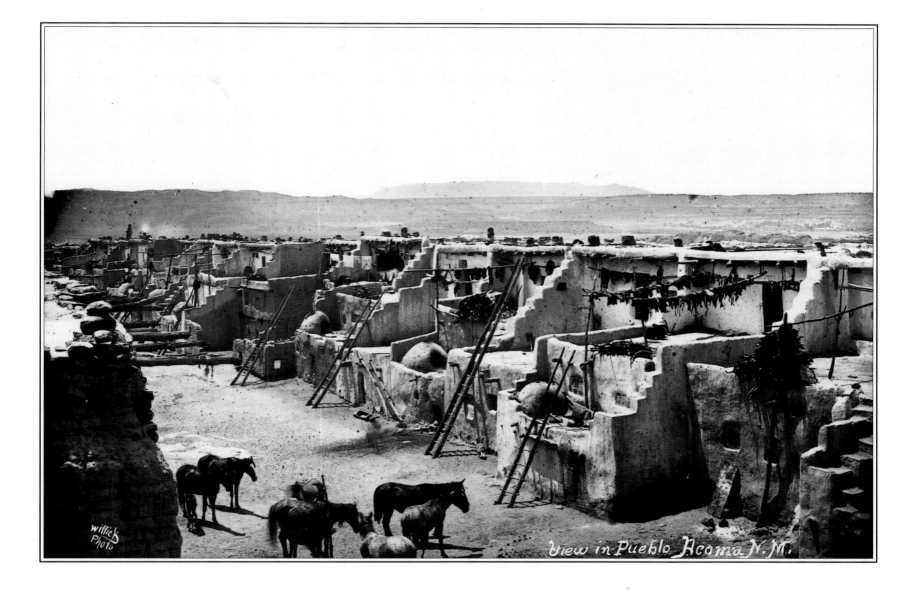

LEFT:
Laura Gilpin
Water Hole, Acoma, New Mexico, 1939

PHOTOGRAPHY COLLECTION
AMON CARTER MUSEUM, FORT WORTH, TX

Ben Wittick
Acoma Pueblo, New Mexico, c. 1883

PHOTO ARCHIVES, MUSEUM OF NEW MEXICO
SANTA FE, NM

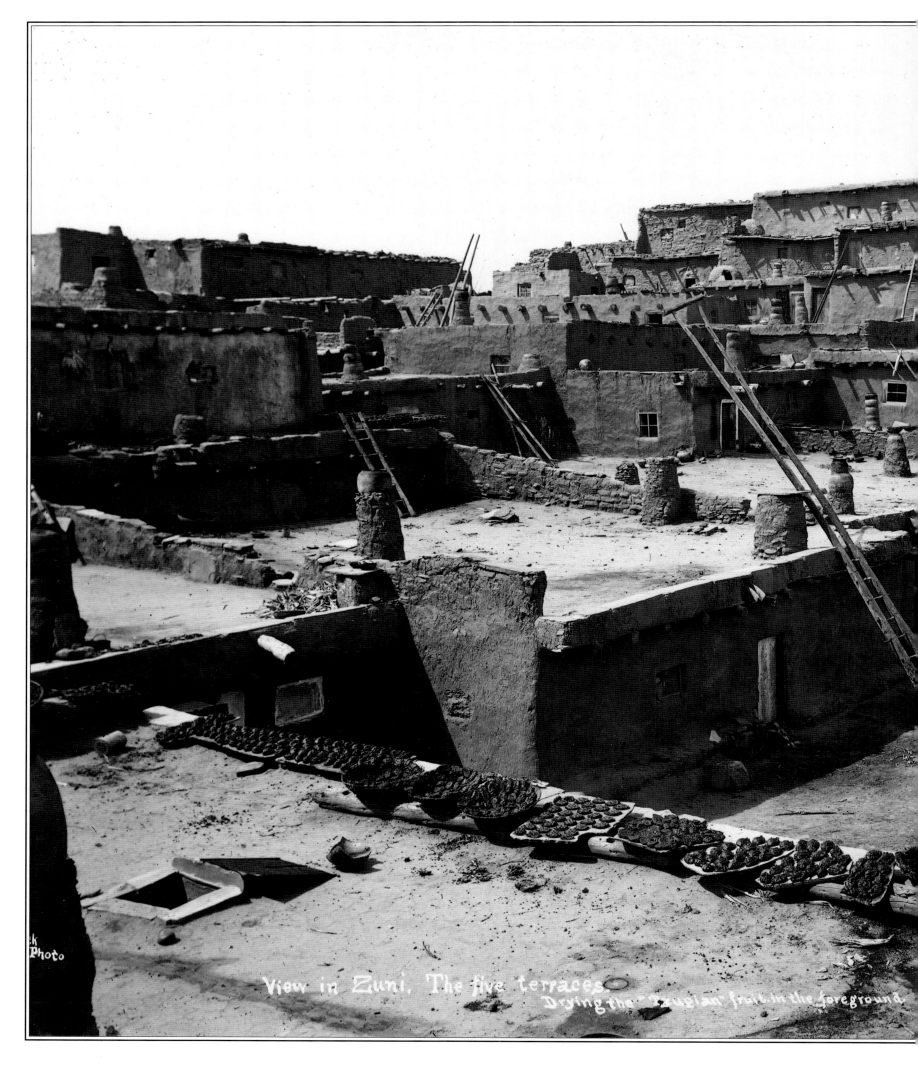

View in Zuni. The five terraces.
Drying the "Tzuelan" fruit in the foreground.

Ben Wittick
The Five Terraces, Zuni Pueblo, c. 1885-90

PHOTO ARCHIVES, MUSEUM OF NEW MEXICO

SANTA FE, NM

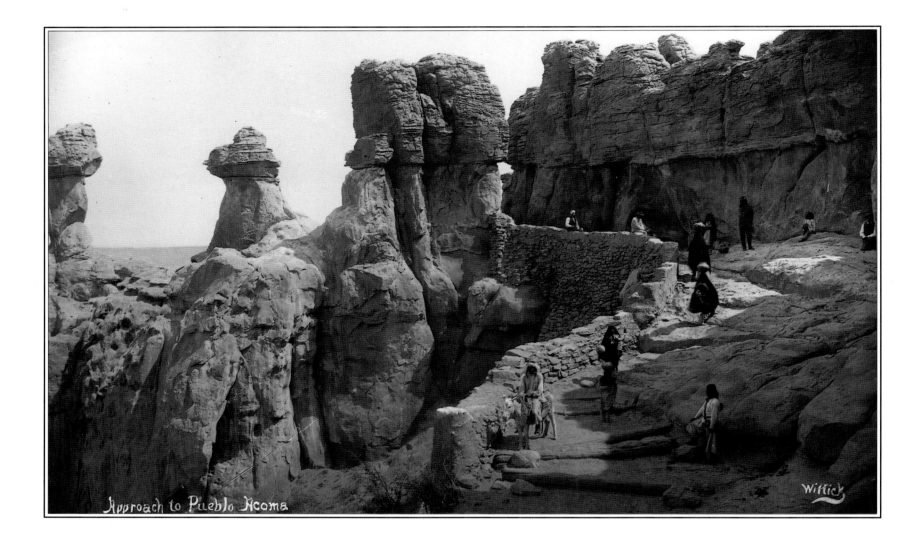

Approach to Pueblo Acoma

Ben Wittick
Approach to Pueblo Acoma, c. 1883

PHOTO ARCHIVES, MUSEUM OF NEW MEXICO

SANTA FE, NM

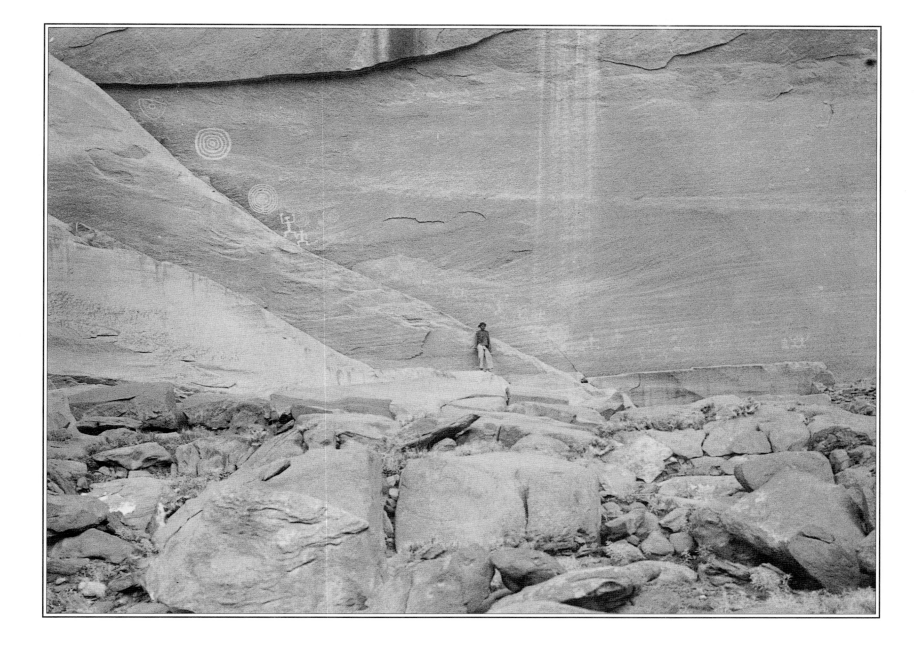

Adam Clark Vroman
Canyon de Chelly, 1904

PHOTOGRAPHY COLLECTION

AMON CARTER MUSEUM, FORT WORTH, TX

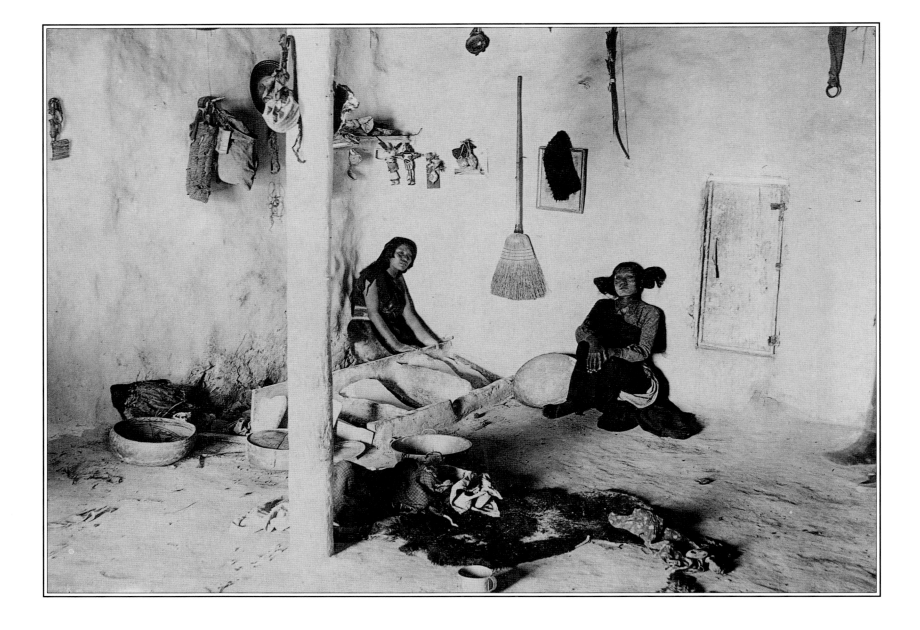

Adam Clark Vroman
Indian Girls Grinding Corn, Moqui Town, 1895

PHOTOGRAPHY COLLECTION
AMON CARTER MUSEUM, FORT WORTH, TX

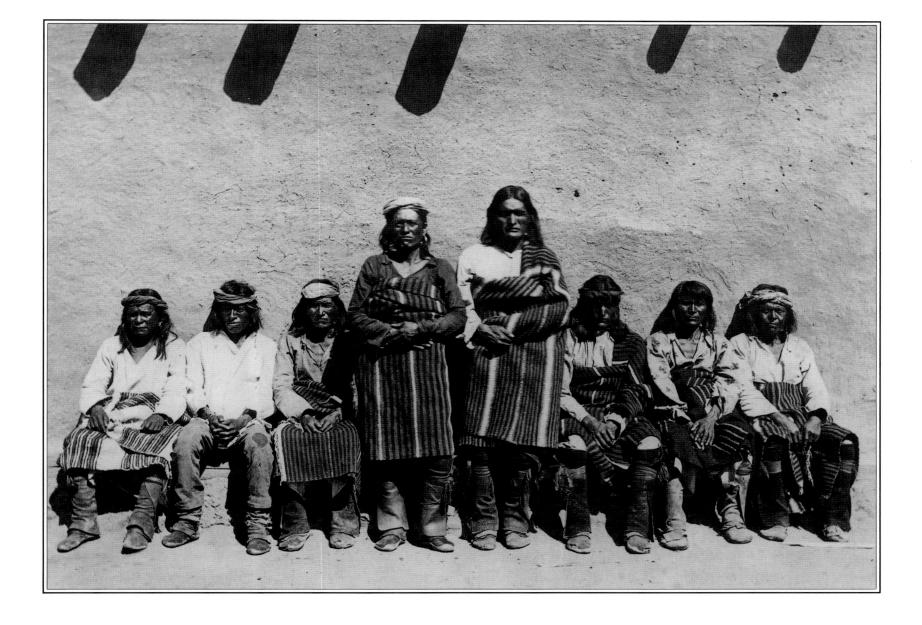

John K. Hillers
A Group of Zuni, Zuni Pueblo, 1880

PHOTO ARCHIVES, MUSEUM OF NEW MEXICO

SANTA FE, NM

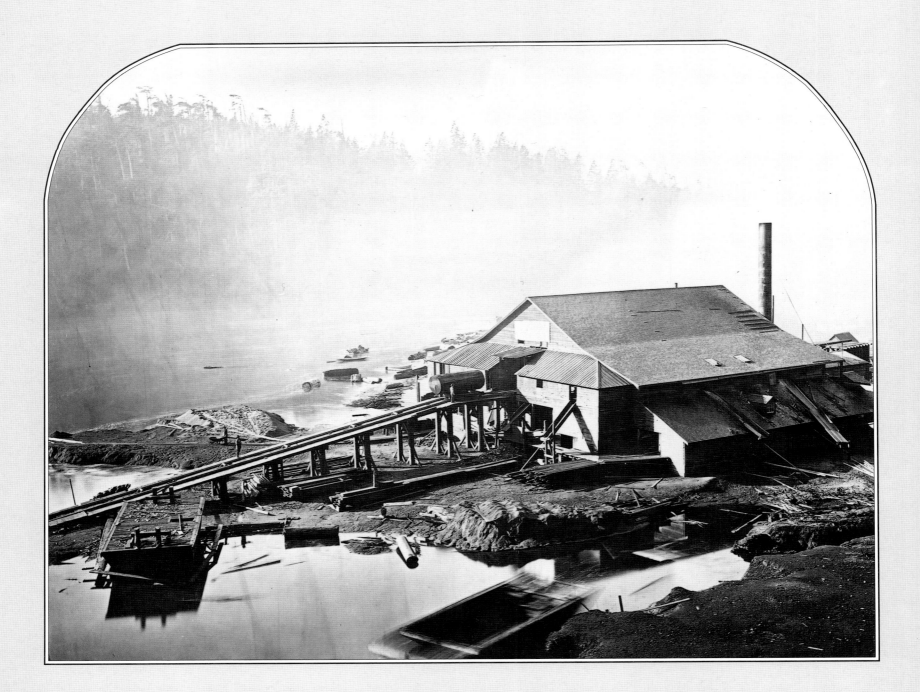

MANIFEST DESTINY

One of history's tragic ironies is that the very photographs that celebrated the splendors of the West contributed to its degradation. Dominating the nation's political and economic discourse during the nineteenth century was the concept of manifest destiny, a phrase first introduced in 1845 by editor John O'Sullivan to urge the annexation of Texas – it was America's "manifest destiny to overspread the continent allotted by Providence for the free development of our yearly multiplying millions." Manifest destiny soon became a popular rallying slogan for those supporting the nation's sacred duty to pursue a policy of territorial expansion. Implicit in this agenda was the need to impose civilization, enterprise and an obviously superior political system on undeveloped regions and their inhabitants. Considered in this light, the western landscape photographs were not just vessels of morally uplifting and spiritually enriching artistic beauty, or an archive of scientific marvels; they also enumerated an unimaginably rich trove of natural resources, ripe for exploitation.

This is not to suggest that photographers Alexander Gardner, Carleton Watkins, A. J. Russell, Timothy O'Sullivan and William Henry Jackson were intentional proponents of manifest destiny, but neither were they its opponents. While they were aware that they were witnesses to a rapidly vanishing world and way of life, they were essentially helpless in preventing its disappearance. The role played by Watkins's photographs of Yosemite and Jackson's photographs of Yellowstone in setting aside those areas as protected parks was the exception. But in the end, the photographers were salaried or freelance employees of organizations that had vested interests in the development of the West. While the government and railroads presented the opening of the West to exploration and settlement as altruism, the desire for profit and the creation of wealth were motives that lay not far below the surface. Hence the photographers became, at times, unwitting propagandists for manifest destiny.

Ever since European colonization, hopes of economic gain had driven the push westward – fur trappers were followed by traders, miners and land-hungry homesteaders. Around mid-century a big impetus came from the successful Mormon settlement of Salt Lake City and the California gold rush, leading to the stupendously costly task of constructing the transcontinental railroad. Understandably, then, the railroads and government sought to recoup their investment by making all possible use of the images produced by their survey photographers.

A scientific record they may have been, but these photographs also were highly useful in publicizing the heroic magnitude of this undertaking and in lobbying Congress for renewed appropriations. The photographs pointed out the West's boundless riches to potential settlers, ranchers, developers and businessmen who, as profitable customers, then would come to depend on the railroad for both passenger and freight service. As a visual affirmation of manifest destiny, this photography subtly and overtly inventoried the fertile plains, grazing lands, abundant timber, mineral reserves, pure waters, accessible transport, docile Native Americans, and diligent farmers and ranchers of the West.

Of necessity, the optimistic boosterism promoting the opportunities of this nirvana downplayed the more disheartening aspects of the western experience. For one thing, the capricious weather could conspire against the best-laid plans. Sensationally bad news did reach the outside world about the cannibalistic Donner party, trapped by snow in the Sierras. Less dramatic but all too frequent were the sad sagas of the Nebraska homesteaders photographed by Solomon Butcher. Droughts wiped out the gains of years of backbreaking labor, and the railways, generous at first with low fares and cheap land to attract settlers, then turned around and charged such high rates to transport produce to market that entire communities withered and died. An isolated case of truth-telling in the realm of manifest destiny was O'Sullivan's remarkable mine shaft views, which pointed out the human costs rather than the financial benefits of mining.

The forces of progress, nevertheless, were indefatigable. When, in a more insidious version of territorial expansion, the railroads built spur lines out to such sites as Yosemite, Yellowstone and the Grand Canyon, the West became a mecca for leisure travelers. In that it attracted tourists in droves, even the uniquely beautiful scenery was profitable.

LEFT:
Carleton E. Watkins
Big River Lumber Mill, 1863

Alexander Gardner
A Bull Train Crossing the Smoky Hill River
near Ellsworth, Kansas, 1867

KANSAS STATE HISTORICAL SOCIETY

TOPEKA, KS

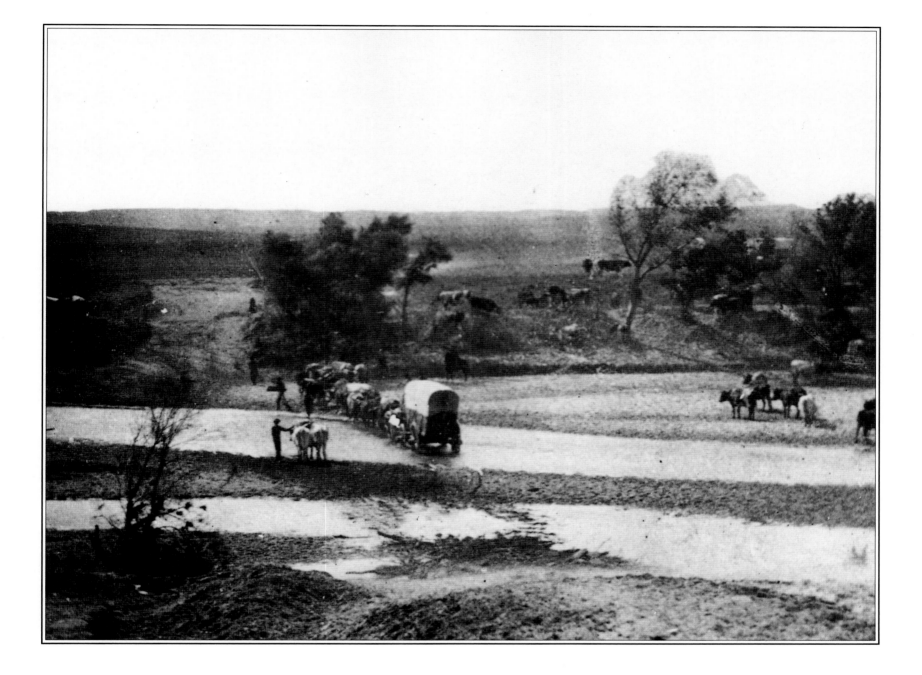

Alexander Gardner
Crossing the Line of Tecolate Creek, New Mexico, 1867

PHOTO ARCHIVES, MUSEUM OF NEW MEXICO

SANTA FE, NM

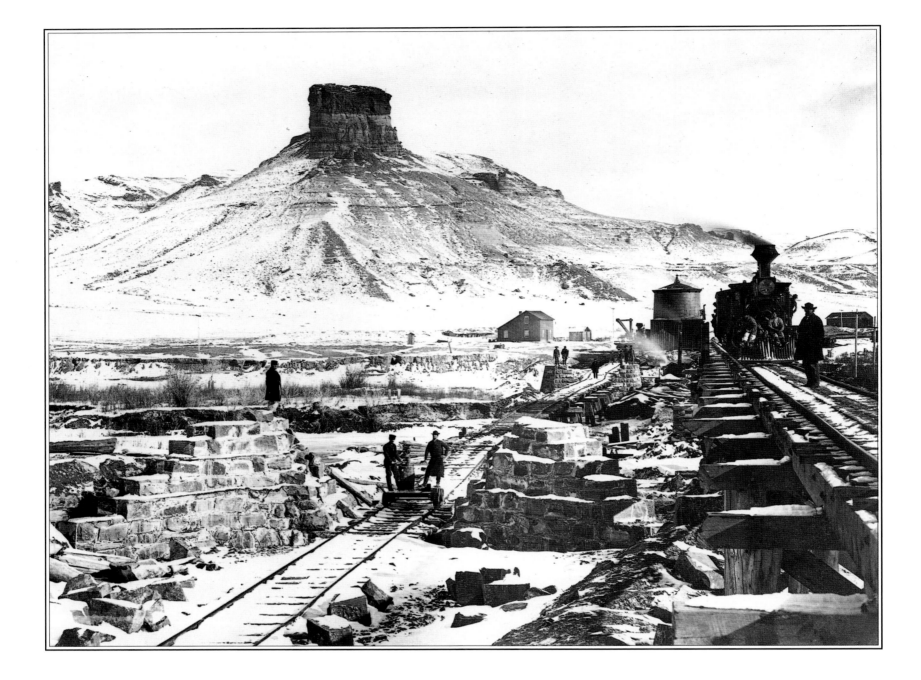

Andrew J. Russell
Temporary and Permanent Bridges & Citadel Rock,
Green River (Wyoming), 1867-68

BEINECKE RARE BOOK AND MANUSCRIPT LIBRARY

YALE UNIVERSITY, NEW HAVEN, CT

Andrew J. Russell

Hanging Rock, Foot of Echo Canyon, Utah, 1867-68

BEINECKE RARE BOOK AND MANUSCRIPT LIBRARY,
YALE UNIVERSITY, NEW HAVEN, CT

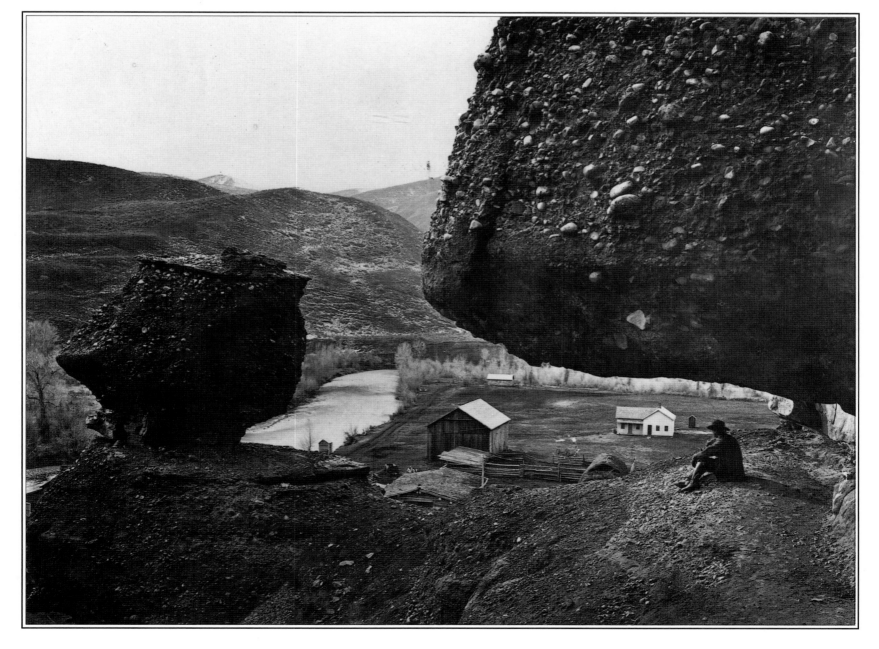

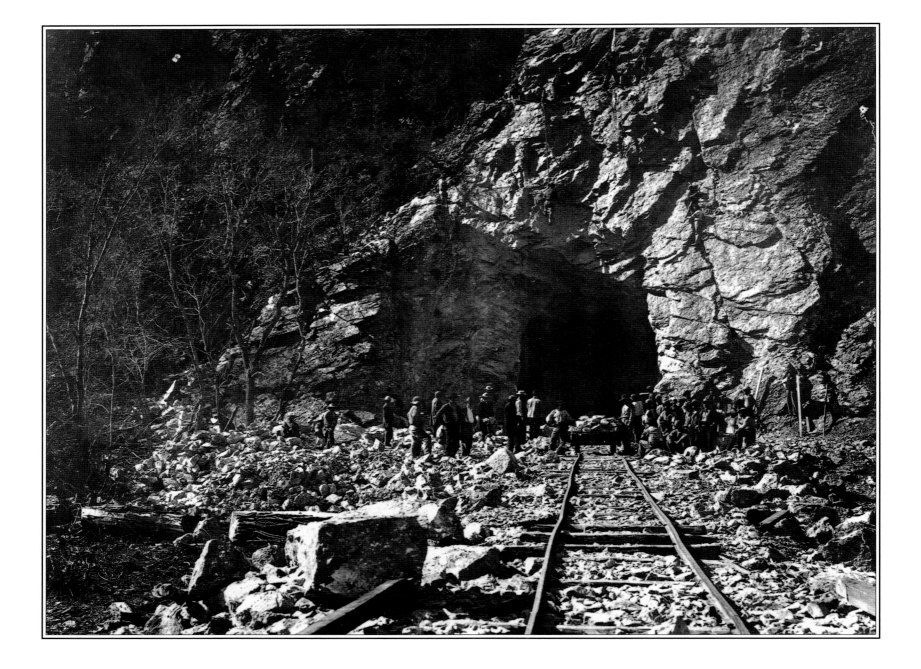

Andrew J. Russell
Building Tunnel No. 3
near Water Canyon (Utah), 1867-68

BEINECKE RARE BOOK AND MANUSCRIPT LIBRARY,
YALE UNIVERSITY, NEW HAVEN, CT

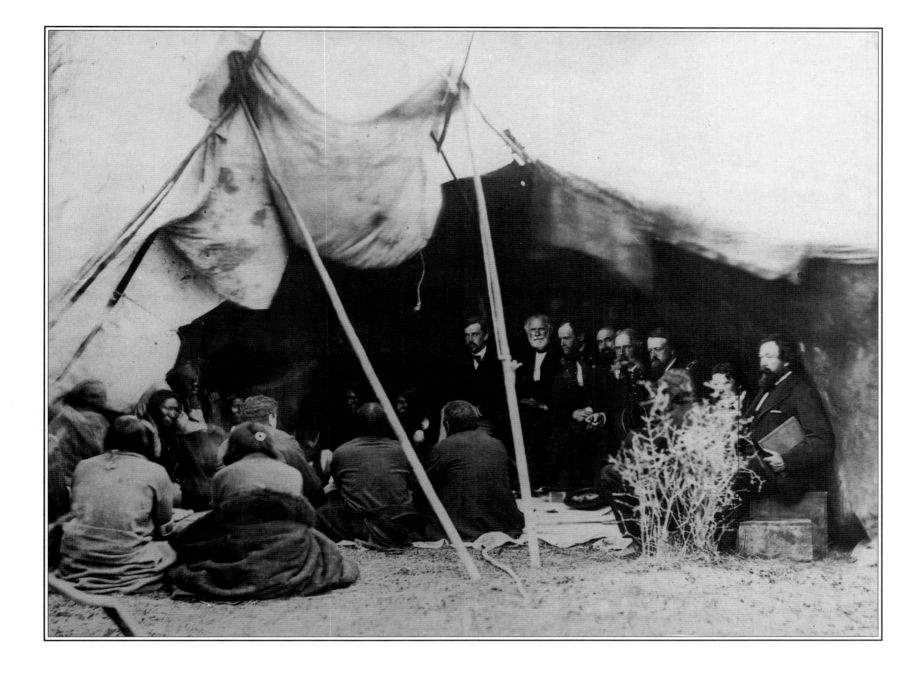

Alexander Gardner
*Treaty of Laramie, Medicine Creek Lodge, Indian Peace
Commissioners in Council with
the Cheyenne and Arapahoe, 1868*

PHOTO ARCHIVES, MUSEUM OF NEW MEXICO

SANTA FE, NM

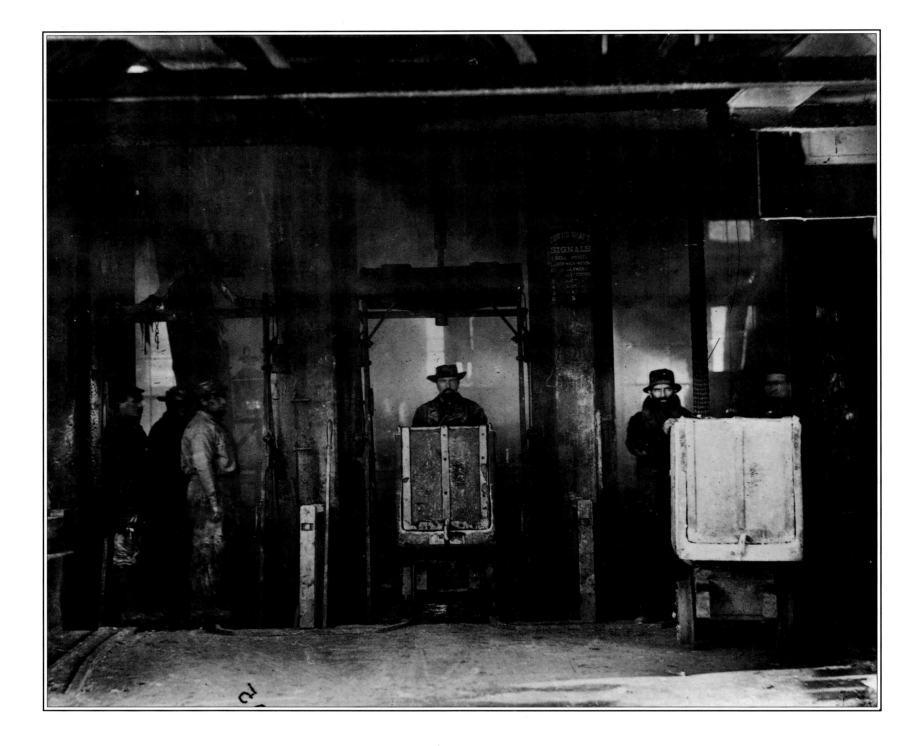

Timothy O'Sullivan
Shaft Mouth, Mining Works, Virginia City, Nevada, 1868

GEORGE EASTMAN HOUSE
ROCHESTER, NY

Timothy O'Sullivan
Crash of Timber in Cave-in, Gould & Curry Mine,
Virginia City, Nevada, 1868

GEORGE EASTMAN HOUSE
ROCHESTER, NY

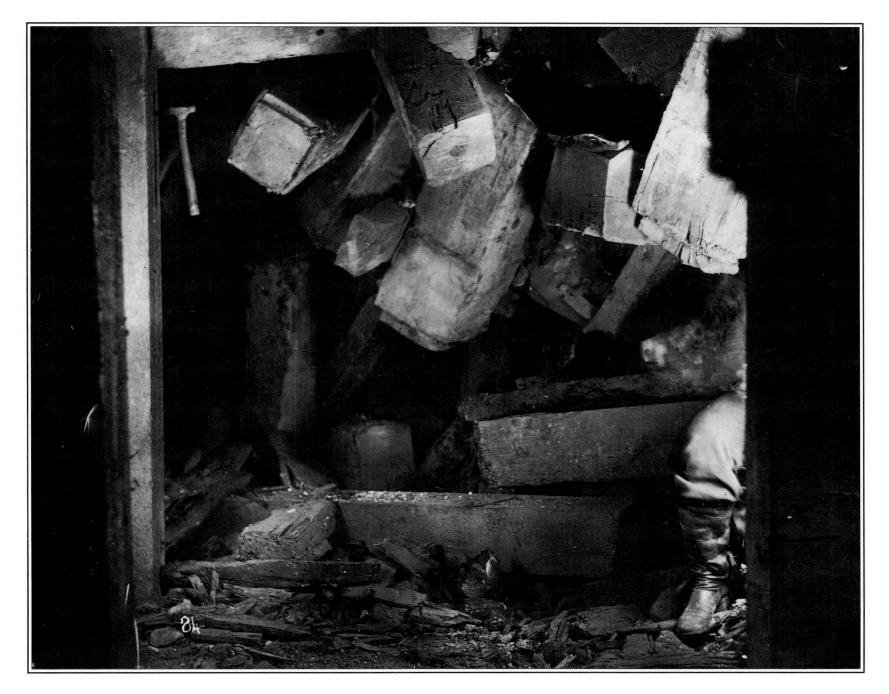

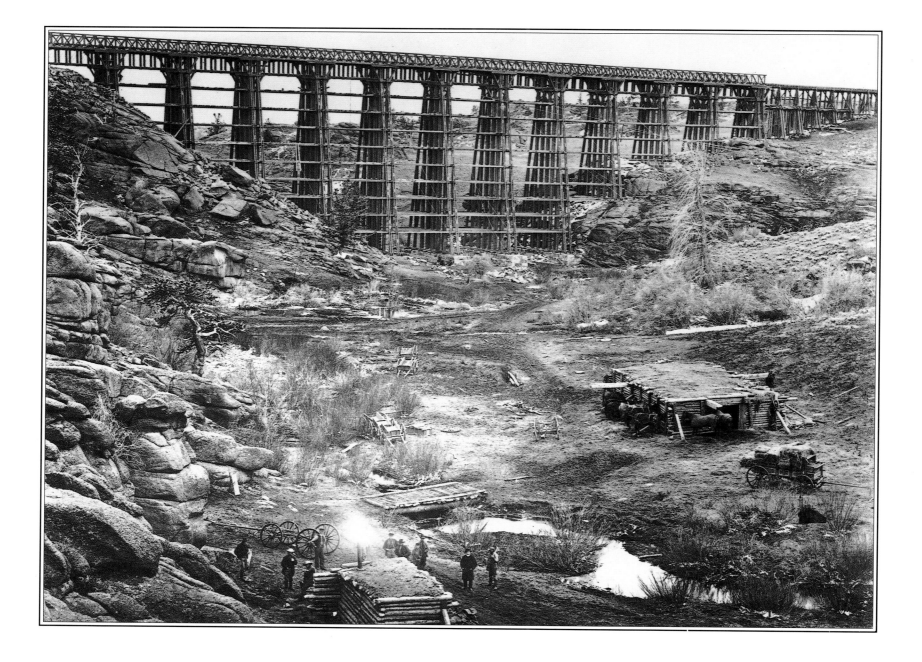

Andrew J. Russell
Dale Creek Bridge, 1868-69

BEINECKE RARE BOOK AND MANUSCRIPT LIBRARY
YALE UNIVERSITY, NEW HAVEN, CT

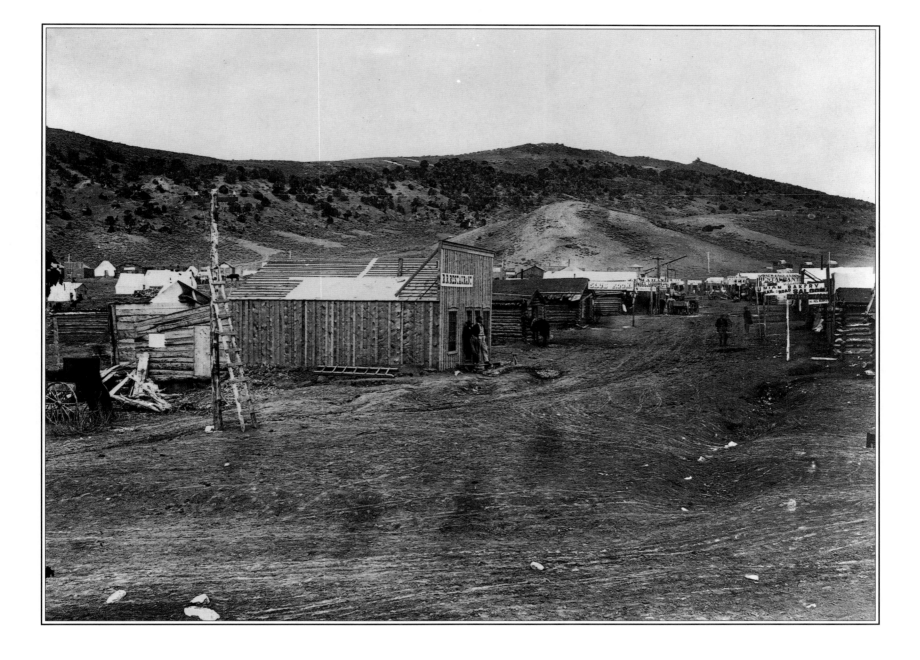

Andrew J. Russell
Bear River City, 1868-69

BEINECKE RARE BOOK AND MANUSCRIPT LIBRARY,
YALE UNIVERSITY, NEW HAVEN, CT

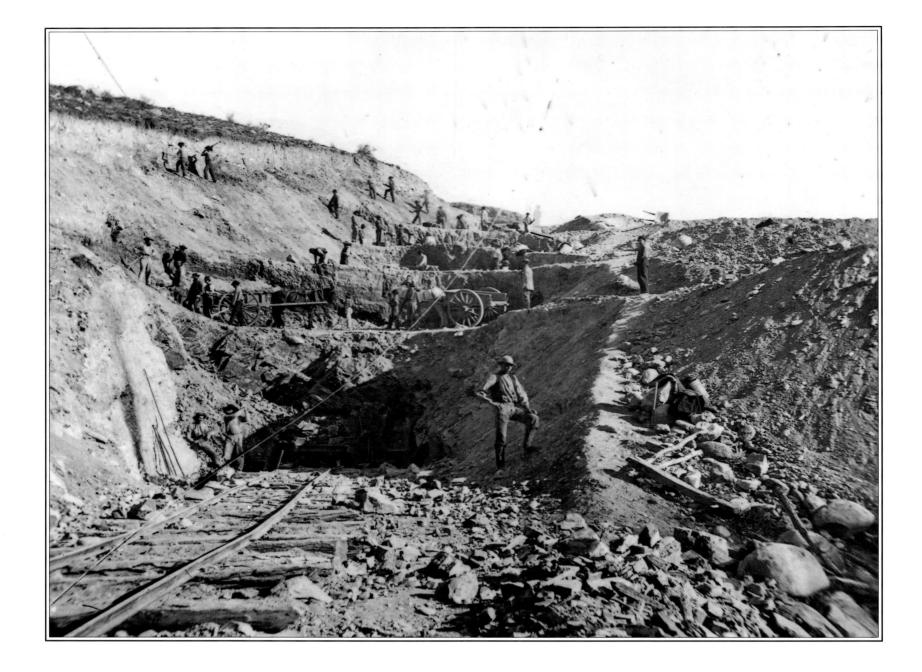

Andrew J. Russell
Weber Canyon, Utah, 1868

RUSSELL COLLECTION
OAKLAND MUSEUM HISTORY DEPARTMENT
OAKLAND, CA

Andrew J. Russell
Driving of the Golden Spike,
Promontory, Utah, 10 May 1869

BEINECKE RARE BOOK AND MANUSCRIPT LIBRARY,
YALE UNIVERSITY, NEW HAVEN, CT

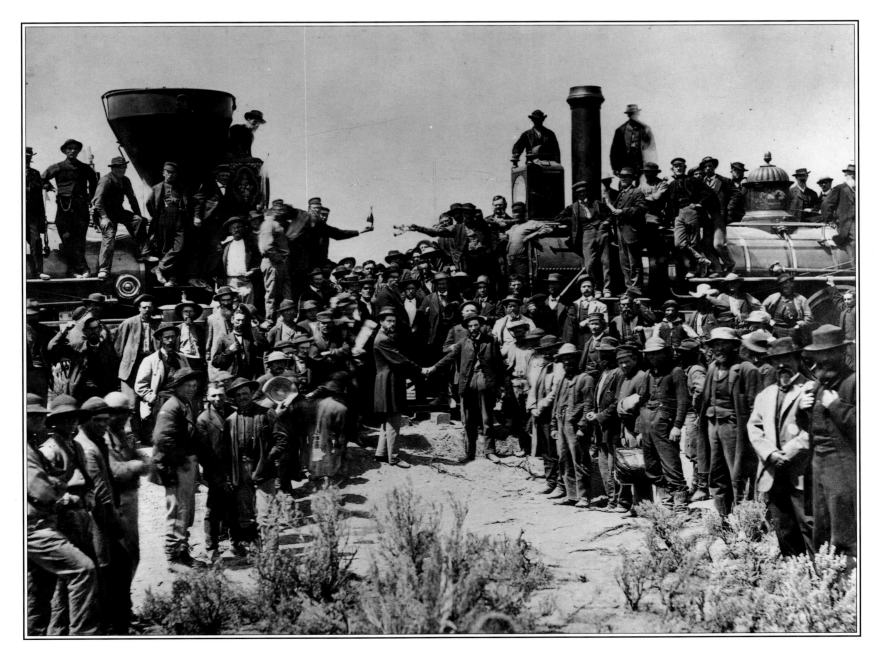

Andrew J. Russell
Construction Train, Outside Ogden, Utah, 1869

BEINECKE RARE BOOK AND MANUSCRIPT LIBRARY,
YALE UNIVERSITY, NEW HAVEN, CT

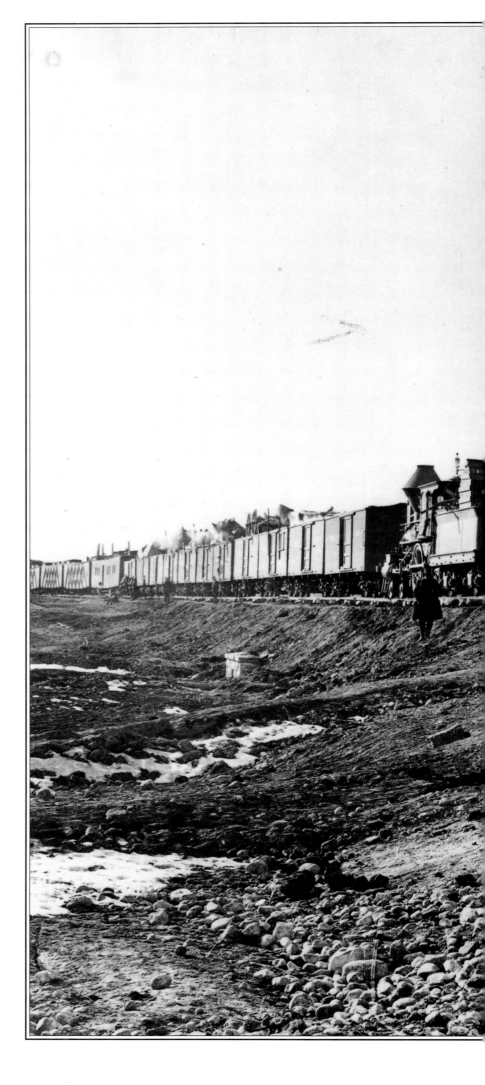

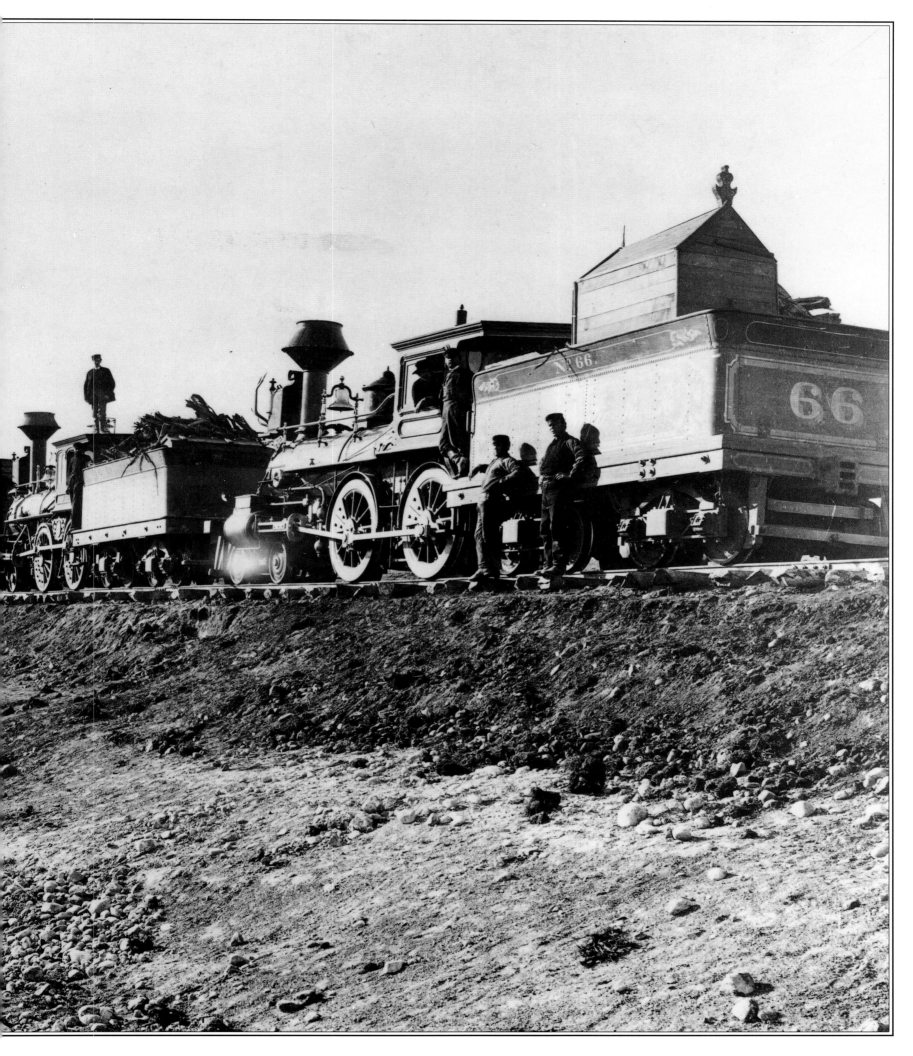

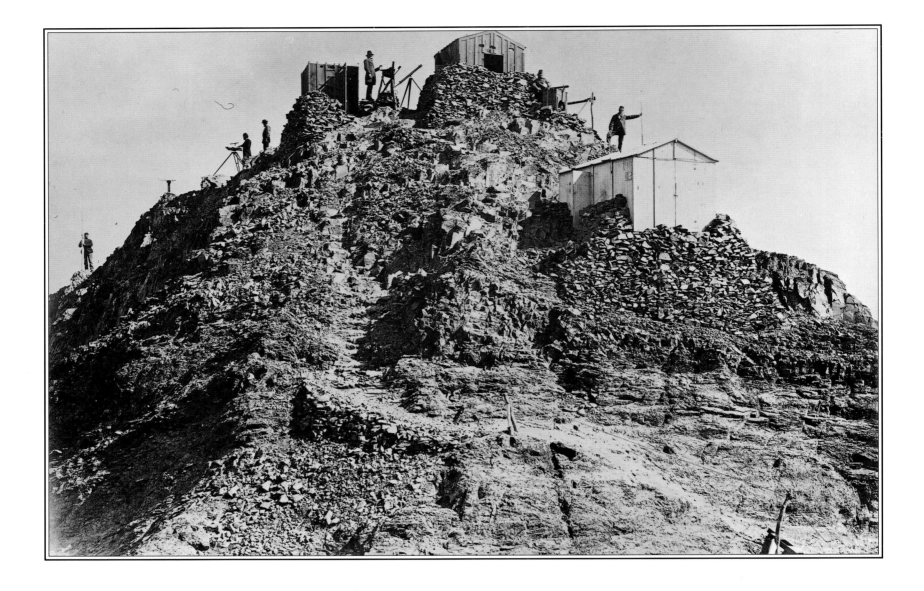

Carleton E. Watkins
Round Top, 1879

RARE BOOK DEPARTMENT, HISTORICAL PHOTOGRAPHS

THE HUNTINGTON LIBRARY, SAN MARINO, CA

Carleton E. Watkins
*Contention Hoisting Works and
Ore Dump from Below, Arizona, 1880*

RARE BOOK DEPARTMENT, HISTORICAL PHOTOGRAPHS

THE HUNTINGTON LIBRARY, SAN MARINO, CA

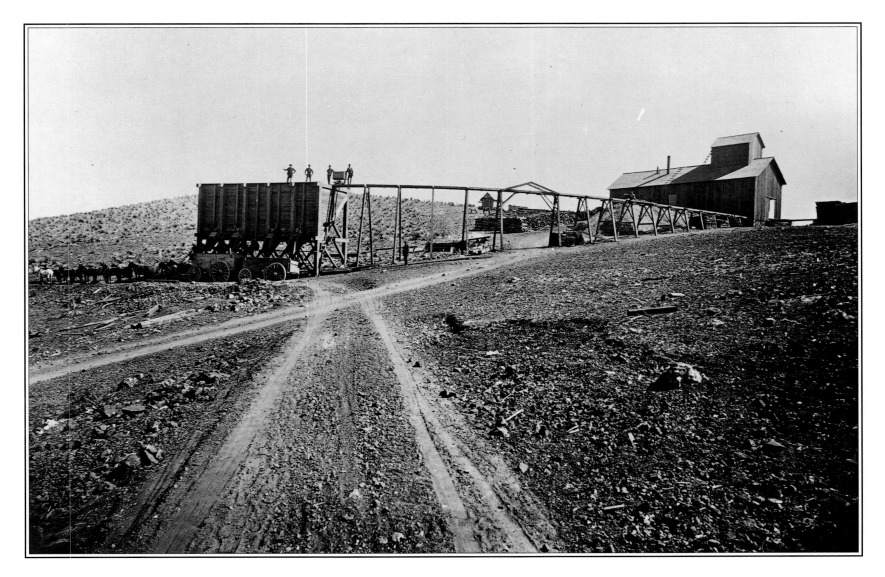

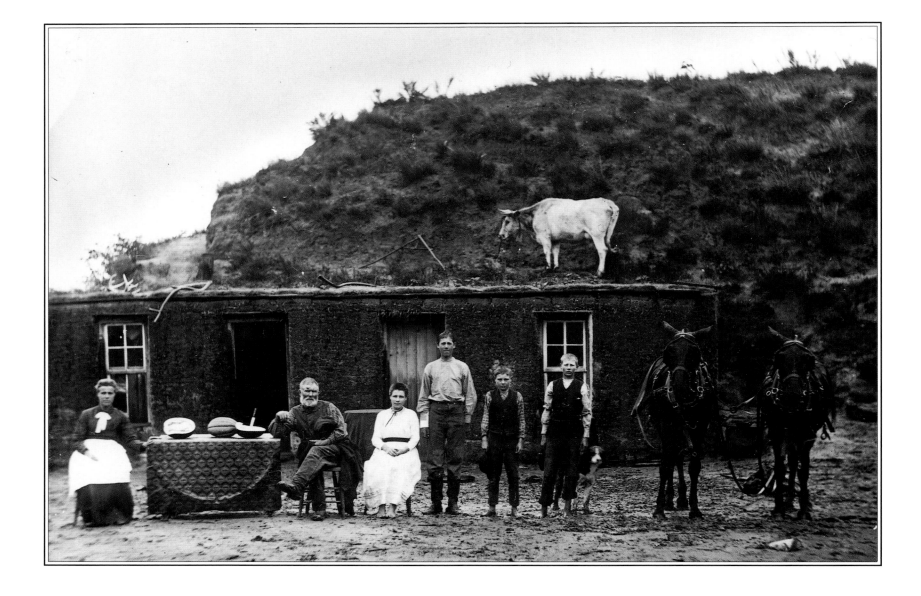

Solomon D. Butcher
Sylvester Rawding House, north of Sargent,
Custer County, Nebraska, 1886

SOLOMON D. BUTCHER COLLECTION,
NEBRASKA STATE HISTORICAL SOCIETY,
LINCOLN, NEBRASKA

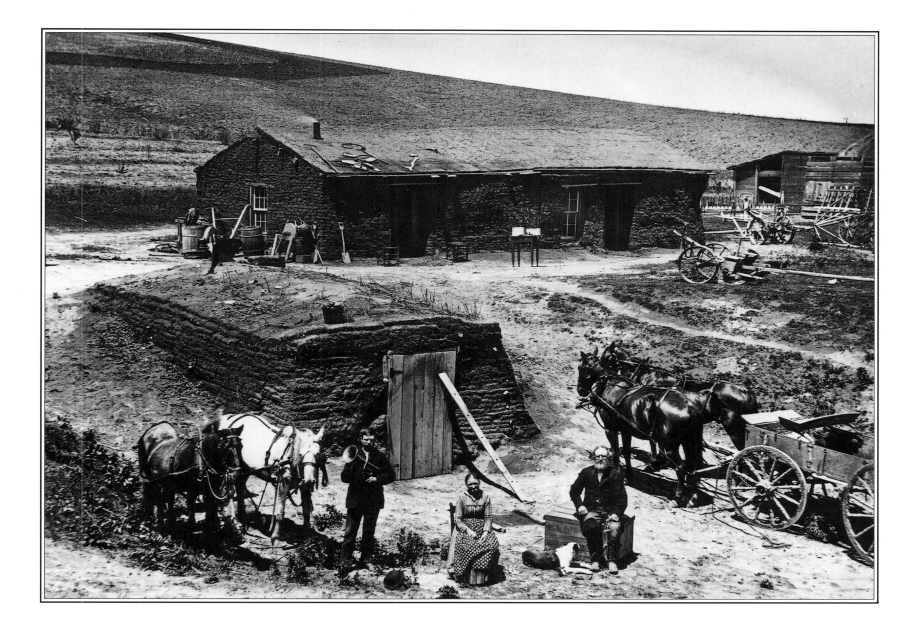

Solomon D. Butcher
The Peter M. Barnes Homestead
near Clear Creek, Custer County, Nebraska, 1887

SOLOMON D. BUTCHER COLLECTION
NEBRASKA STATE HISTORICAL SOCIETY,
LINCOLN, NEBRASKA

Solomon D. Butcher
The Shore Family, Negro Homesteaders, 1887

SOLOMON D. BUTCHER COLLECTION
NEBRASKA STATE HISTORICAL SOCIETY,
LINCOLN, NEBRASKA

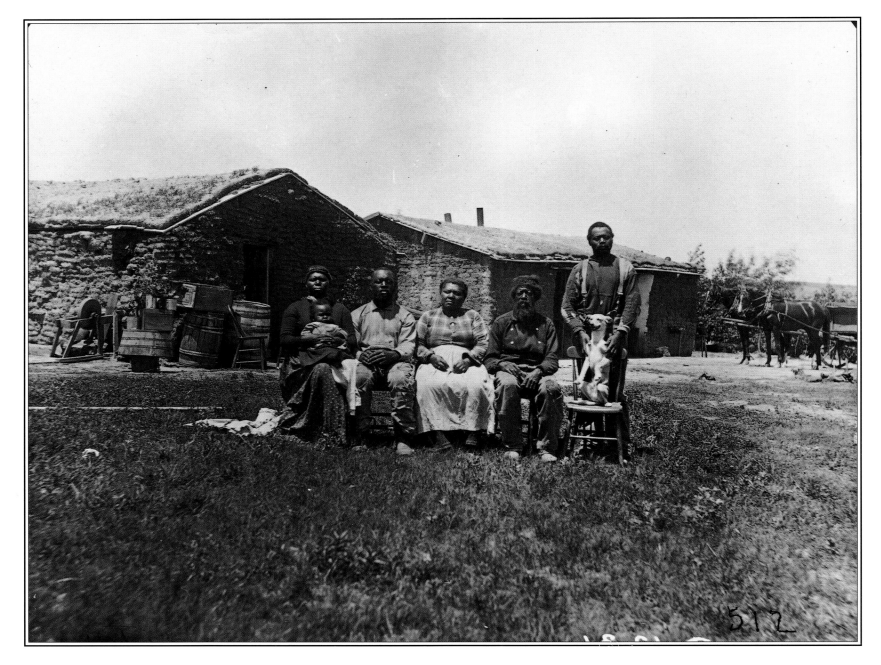

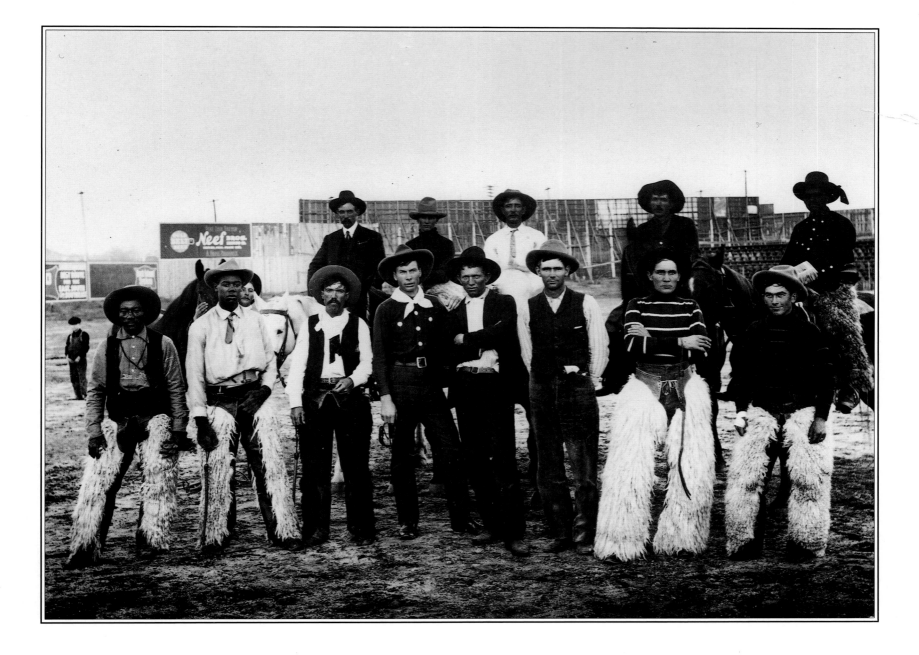

Solomon D. Butcher
Cowboys in Denver, Colorado, 1901

SOLOMON D. BUTCHER COLLECTION
NEBRASKA STATE HISTORICAL SOCIETY,
LINCOLN, NEBRASKA

LIST OF PHOTOGRAPHS

ANSEL ADAMS
Cliff Dwellings, Mesa Verde National Park 68-9
Evening, McDonald Lake 32-3
The Giant Dome, Largest Stalagmite thus far Discovered 47
Grand Canyon from the South Rim 36-7
Jupiter Terrace – Fountain Geyser Pool 35
Navajo Woman and Infant 78

SOLOMON D. BUTCHER
Cowboys in Denver, Colorado 111
The Peter M. Barnes Homestead 109
The Shore Family 110
Sylvester Rawding House 108

EDWARD S. CURTIS
Buffalo Dance at Hano 74
Chief Joseph, Nez Perce 72
Placating the Spirit of a Slain Eagle – Assiniboin 75
The Vanishing Race – Navaho 73
Winnowing Wheat – San Juan 76-7

ALEXANDER GARDNER
A Bull Train Crossing the Smoky Hill River 92
Crossing the Line of Tecolate Creek 93
Treaty of Laramie, Medicine Creek Lodge 97

LAURA GILPIN
Navajos by Firelight 80
Water Hole, Acoma, New Mexico 82

F. JAY HAYNES
Grotto Geyser Cone 60-1

JOHN K. HILLERS
A Group of Zuni 89
A Hopi Hairdresser 70
Reflected Cliff, Green River, Ladore Canyon, Utah 29
View from Face Rock, Canyon de Chelly 53

WILLIAM HENRY JACKSON
Columnar Basalts on the Yellowstone River 31
Crater of the Lone Star Geyser 58
Grand Canyon of the Colorado 55
Grand Canyon of the Yellowstone River 25
Mammoth Hot Springs, Yellowstone 57
Moraines on Clear Creek, Valley of the Arkansas 45
North from Berthoud Pass 4-5
Mountain of the Holy Cross, Colorado 26-7
Old Faithful in Eruption 46
Pawnee Men Before Earth Lodge 71
Rocks Below Platte Canyon (Colorado) 42-3
Upper Fire Hole from Old Faithful 56

EADWEARD MUYBRIDGE
Donald McKay, the Celebrated Warm Springs Indian
 and his Chief Scout 66

Falls of the Yosemite from Glacier Rock 20
Loya, Valley of the Yosemite 39
Tenaya Canyon, Valley of the Yosemite 38

TIMOTHY O'SULLIVAN
Aboriginal Life Among the Navaho Indians 67
Ancient Ruins in the Canyon de Chelly 2
Canyon of the Colorado River near Mouth of
 the San Juan River 54
Crash of Timber in Cave-in 99
Sand Dunes, Carson Desert 40
Shaft Mouth, Mining Works 98
Shoshone Falls, Snake River, Idaho 22-3
Tufa Domes, Pyramid Lake 50-1
Two Mohave Braves 79

ANDREW J. RUSSELL
Bear River City 101
Building Tunnel No. 3 96
Construction Train, Outside Ogden, UT 104-05
Dale Creek Bridge 100
Driving of the Golden Spike 103
Hanging Rock, Foot of Echo Canyon 95
High Bluff, Black Buttes (Wyoming) 44
Serrated Rocks or Devil's Slide 52
Skull Rock, Sherman Station 49
Summit of Mount Hoffman 24
Temporary and Permanent Bridges & Citadel Rock 94
Trestle at Promontory, Utah 1
Weber Canyon, Utah 102

WILLIAM SOULE
War Chief of the Arapahoe, Powder Face 62

ADAM CLARK VROMAN
Canyon de Chelly 87
Indian Girls Grinding Corn, Moqui Town 88
Two Women by Pots 81

CARLETON E. WATKINS
Big River Lumber Mill 90
Contention Hoisting Works and Ore Dump 107
The Domes from Sentinel Dome 34
First View of the Yosemite Valley 30
Grizzly Giant, Mariposa Grove 59
Mirror Lake, Yosemite 28
Round Top 106
Washington Columns, Yosemite 18
Yosemite Valley from the Best General View 21

BEN WITTICK
Acoma Pueblo, New Mexico 83
Approach to Pueblo Acoma 86
The Five Terraces, Zuni Pueblo 84-5
View of Chalcedony Park, Petrified Forest 48
White House Ruins, Canyon de Chelly 64-5

Photo Credits
Beinecke Rare Book and Manuscript Library, Yale University: 11(top left), 13.
The Bettmann Archive: 8(top, bottom right), 9(all three), 10(bottom left), 14(center right).
Amon Carter Museum, Fort Worth, TX: 16(bottom).
Chicago Historical Society: 12(top).
Denver Public Library, Western History Department: 14(top left).
Henry E. Huntington Library and Art Gallery, San Marino, CA: 10(top).
Library of Congress: 6, 7(top), 8(bottom left).
Museum of New Mexico, Photo Department: 12(bottom), 16(top).
Eadweard Muybridge Collection, Kingston upon Thames Museum and Art Gallery: 10(bottom right).
National Archives: 17.
Nebraska State Historical Society, Solomon D. Butcher Collection: 14(bottom).
Oakland Museum History Department: 11(top right).
Frederic Remington Art Museum, Ogdensburg, NY: 7(bottom).
University of Washington Libraries, Special Collections Division: 15(both).

Artwork
Page 11(bottom): Frederic Remington
Buffalo Hunter at Full Gallop Loading His Gun with His Mouth, 1900
Oregon Trail by Francis Parkman
Wash drawing
Frederic Remington Art Museum, Ogdensburg, NY

Acknowledgments
The author and publisher would like to thank the following people who helped in the preparation of this book: Mike Rose, the designer; Susan Bernstein, the editor; and Rita Longabucco, the photo editor. For their invaluable help we would like to thank Arthur Olibas and the photo division of the Museum of New Mexico and George Miles of the Western Americana Collection, Beinecke Library at Yale University.